# As I Am

By Julian C. R. Okwu

# As I Am

*Young African American Women in a Critical Age*

CHRONICLE BOOKS

SAN FRANCISCO

Copyright © 1999 by Julian C. R. Okwu

All rights reserved. No part of this book may be reproduced in any form without written permission from the publisher.

Library of Congress Cataloging-in-Publication Data available.

ISBN 0-8118-2073-4

Printed in Hong Kong.

Book and cover design: Sandra McHenry Design

Distributed in Canada by Raincoast Books
8680 Cambie Street
Vancouver, British Columbia V6P 6M9

10 9 8 7 6 5 4 3 2 1

Chronicle Books
85 Second Street
San Francisco, California 94105

www.chroniclebooks.com

*As I Am* is dedicated to African American women everywhere, who have been the root and foundation of our families through time.

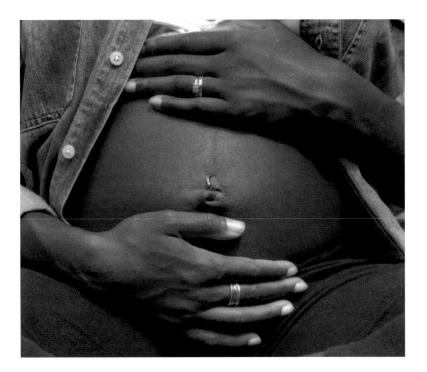

And to my parents, Drs. Beatrice and Austine Okwu, who have withstood life's toughest challenges on soil that was not their own. Your examples are truly the brightest.

# Acknowledgments

First and foremost, I am indebted to the thirty-six women who agreed to be a part of this book. My heartfelt gratitude goes out to each and every one, as does my appreciation for being allowed the privilege of sharing their emotions and their lives with you. In every instance, even at times when my timing for an interview or a photo-shoot could not have been worse, I was greeted with a smile, often a hug, and always with sincerity.

People commonly ask me how I was able to find these exemplary women. The most popular way was through the grapevine, that is, John Bryant, Mousumi Das, Crystal Hayling, Heather Hiles, Gerta Govine, Michelle Genece, Ben Jealous, Christopher Johnson, Martin Jones, Judy Krasnick, Steven Malk, Francis Okwu, Muriel Pearson, Tyrone Porter, Darieck Scott, Angela Singleton, Dee Dee Terzian, Leifer and Yvette Bonaparte Thor, Leslie Williams, and Michael Woolsey. Thank you for directly, or indirectly, facilitating my introductions.

This is the second time I have published a book with Chronicle Books. Not many authors are as lucky with their publisher as I have been with my mine. My special thanks to all the employees who consistently made me feel comfortable and were involved in seeing this project through to completion, including my editorial team of Sarah Malarkey and Mikyla Bruder.

I remain eternally grateful to André Cypriano, whose extraordinary ability in the darkroom produced these superb photographic prints. His understanding of the various permutations born from a single negative has tirelessly complemented my photography for years.

Once again, I have been able to enjoy the process of making a book rather than getting bogged down under the weight of work. This was made possible through the extraordinary support and encouragement of my friends; my brothers, Michael Chiaka, Oscar Nnamdi, Francis Chiedo, and Augustine Nkem; and the life that is my love, Anja McClellan.

Thank you all for being an integral part of *As I Am*.

# Contents

# As I Am

Young African American Women in a Critical Age

# Introduction

I have heard it, or variations of it, many times: "My mother is the most incredible person in my life," or "I can attribute my success to my mother's example." Not to trivialize the contributions of our fathers and the many exceptional men who have risen above society's challenges, but it has been the women, particularly African American women, who have held families together for generations. I grew up in a Nigerian family of six men—my father, four older brothers, and myself—and one woman: my mother. It was apparent to all of the children that, although we could never compare the adversities either one of our parents had to face, our mother was the one with the extra burden. Not only did she have to overcome all of the obstacles of being a black face in a new country populated by a white majority, just as our father did, but she had the additional responsibility of maintaining the consistent cohesion of our family. That was my first exposure to the added weight women bear. That understanding serves as the starting point for *As I Am: Young African American Women in a Critical Age*.

This book is an obvious companion to my first book, *Face Forward: Young African American Men in a Critical Age*, but the need for it only became clear to me as I was waiting for the first book to be published. I had a transformative lesson one evening in 1997 when I accepted a friend's invitation to attend a meeting for women of color at a bookstore in San Francisco. The event was a book reading and a forum to discuss important issues, and the debate on this particular day was interracial dating (the group would have been hard-pressed to find a more lively topic). The discussion was developed and heated, intellectual and passionate, among a store full of African American, Latina, Asian, and a few white women. And though the three other black men and I who were there had seemingly signed an agreement to remain as silent observers, in fact I had a difficult time honoring that pact. But, when I *did* speak, my words were received by the women in attendance with nothing less than intrigue and a desire to bridge the gap between black men and women. The event was a pleasure to be a part of, and because of it I solidified my intention to create a forum for the erudition, complexity, diversity, pain, and passion of young African American women.

Though I believed strongly in the idea of a book honoring black women aged thirty-five and under who have contributed to society in a positive way, I became increasingly concerned about the effect my gender would have on the integrity of such a project. Would women speak frankly

with me? Would they trust me with their innermost thoughts? Could my photography convey their spirit and avoid depicting them as objects? Should I have someone else conduct the interviews? Should I enlist the services of a female photographer? With these questions in mind, I started to publicize *Face Forward*. During an online interview with a major bookseller, I fielded a question from a woman in Washington, D. C., that galvanized all my fears. After hearing about my future plans, she asked, "What makes you think that, as a man, you can convey what women think about themselves?" As I look back on it, I am grateful for her bluntness, for she gave me the opportunity to begin to formulate in words my intention for *As I Am*. My desire, as I said to her, is to be a conduit of personal expression and not an interpreter of thoughts and ideas. Hopefully, such an approach will allow young, African American, female voices to be heard by girls *and* boys looking for role models, as well as by people who have not had the fortune to be exposed to their ideologies.

My goal with this book—as it was for *Face Forward*—is to facilitate a discourse on diversity, to introduce an array of seemingly invisible and silenced citizens, and to promote the triumph of the human spirit over adversity. When you read about author Danzy Senna's understanding of her racially mixed background, the surprising comments hurled during television executive Kathy Busby's Hollywood meetings, and Theresa Jones's victory over cancer, then it will be easy for you to see why it was an honor for me to embrace these thirty-six new women in my life. Teiahsha Bankhead, who was one of the first interviewed, summed up my participation as a photographer, an author, and a man as a symbolic bridge between black women and black men. The division and lack of understanding between the sexes is not as pervasive as we tend to believe. Taking the time to listen to these giving and exemplary women proved many things to me—not the least of which was that, despite the obvious, and sometimes subtle, differences in perception men and women may have, we share a singular vision for our future and that of our children: that is, the hope that they will suffer to a lesser degree the alienation we often feel as black people.

I entered into this world of publishing because of one racist and unforgettable experience on the corner of a San Francisco street six years ago. As I stood on that corner pondering how my gender and skin color could have such a profound and negative effect on a fellow human being, my path was revealed to me. My hope for those of you who have the courage, patience, and

open-mindedness to read this book—reserving judgment until its final page—is that something uplifting, albeit often elusive, will be revealed to you. It is the distinct diversity, inexorable strength, enviable resilience, and rousing inspiration of young African American women. But that's enough from me. The most eloquent spokespeople for the heart of *As I Am* come forward once you turn this page.

—*Julian C. R. Okwu*

# Ayana Goore

Born November 29, 1971, East Orange, NJ     *Construction is still a man's world, but Ayana is changing that every day just by going to work. Ayana received her master's degree in civil engineering from Stanford University in 1996, and now she is one of about a hundred superintendents at Structure Tone, a construction company. She loves construction and enjoys her job for two main reasons: one, she likes the notion that something you build can serve as a lasting monument to your hard work, and two, she can employ African Americans. She lives in East Orange, New Jersey.*

My parents were divorced when I was ten. My mom is a very strong woman who will do whatever it takes to get through a challenge. There was a time when we didn't have any money, but somehow she kept us in private schools even though it was difficult. We ended up getting scholarships, since otherwise she wouldn't have been able to afford it. As a result of these struggles, we are a very close family, and whatever one of us needs, somebody else is willing to give.

I hope I have some of my mother in me. The company I work for has had only one woman superintendent before me. At the moment, I am the only one. I am happy that they gave me the opportunity, but I don't like feeling that I am some sort of exception. That is the feeling I get. The first week I was here one female coworker asked me why I was in the position I was in. She went on to ask me if the reason was because I didn't know how to type. Here was a woman automatically assuming that I should be a secretary. As a matter of fact, there were several times when I was asked by women and men—inside and outside of the company—if I was the project manager's secretary. The biggest compliment a woman rising in the ranks may receive is that she's down to earth. If a woman touts herself like a man does, she would be called a bitch. Men don't want to work with a woman who is aggressively confident. On its own, confidence is okay. But aggressively confident? No way.

With that said, I don't feel like I'm an anomaly in this environment because I know I am in my element. But other people may see a difference. Most of the meetings I sit in are made up of all men except for me. I'm generally the only one who looks different. There are about one hundred superintendents in our company, and when we meet, maybe fifty of us show up at a time. During one of those meetings, someone was speaking and every sentence was full of curses. Each time he cursed he looked at me and said, "Oh, sorry." A lot of the older guys act like that. And maybe

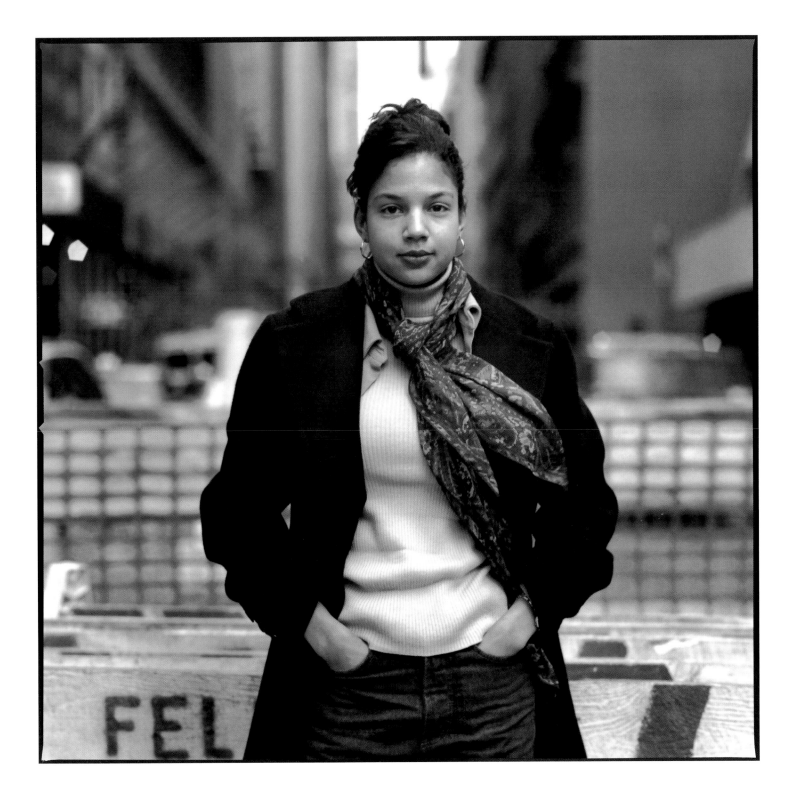

it was his way to not offend me, but there's a catch-22 that occurs at moments like that. If this is the way men behave in construction, then I have to accept it if I want to be here. On the other hand, I don't expect people to go around grabbing their crotches, spitting everywhere, or doing whatever it is that they do around other men—especially if they don't act like that around their wives, daughters, and mothers. I am a woman and I deserve the same respect. I am still looking for that balance.

Instead of taking the time to get to know me, men in this business sometimes assume I don't know anything because I am young. They often try to get away with stuff, like not doing the work. But I also experience the opposite of that. Once, two of my clients who are white women told me that when I got on the job they felt like everything started running smoothly. I hadn't done anything up to that point. I think they were just happy, or more confident, that they wouldn't be cheated by me because I was a woman. There are also some advantages to being young. Because of my age a coworker who may know more than I about a specific part of this job might take half an hour to show me how to do something. If I were older, they might not help at all. Part of it is because they don't feel threatened by me, and another part of it is that some of them are happy to see a black person or a woman in this position.

When people start to act funny with me, I don't know if it is because I'm a woman, I'm young, or I'm black. I remind them that I'm just here to get the work done. It's a good day when people show up on time and have their materials and are doing the work. It's a better day if people get their job done and I'm not called a bitch. I try and preserve a balance of expressing the idea that we can be down and cool with one another, but at the same time, we can get the work done and treat each other with respect. And that's all I expect.

I'm trying to stick with this for now, but I know that I am looking at other things. I am a versatile person, and I think I was meant to follow my heart. Right now I love construction and what I do. The only way to do something well is to really enjoy it. There are a lot of people who are interested in making quick money and are very unhappy. Because I am happy, I feel like this is what I was meant to do. Actually, I don't know if "meant to do" is the right phrase because when you say that you start limiting yourself. I don't want to feel like walls are closing in and I can only do this one particular thing.

There are so many things to do, but we first have to take steps toward them. That's one reason why I didn't agree with the Million Man March [in 1995]. Instead of people taking a day off and promoting hype and image, I'd rather see us all make it to work on time. Rather than proclaiming what you are going to do, just get up and do it. People should have taken that day to write down ten steps that would lay out how they were going to get there. When you do that, you have smaller steps you can gauge your improvement by instead of looking at something that seems unattainable. Even if you don't reach that tenth step, at least you can improve on where you were.

Ayana Goore

# Rebecca Walker

Born November 17, 1969, Jackson, MS          *It is no surprise, perhaps, that the daughter*
*of acclaimed writer Alice Walker is a committed political activist and writer herself.*
*As she was graduating from Yale University in 1992, Rebecca felt the political climate*
*in this country was missing an essential voice: that of the young generation. She and*
*Shannon Liss cofounded the organization 3rd Wave to inspire leadership and activism*
*among young women and to counter the slacker perception of the twenty-something*
*generation. 3rd Wave now has chapters around the country, and in 1997 the organi-*
*zation awarded $180,000 in grant money to young women of conscience. Rebecca's*
*first book,* To Be Real *(1995), is a critical look at the current feminist movement, and*
*it has already been incorporated in college curriculums. She is currently working on*
*two more, including an autobiography that deals with growing up biracial. Somehow*
*she has also found time to pursue an acting career, recently appearing as a reporter in*
*the movie* Primary Colors. *She lives with her partner, Bashir, and their son, Cory, in*
*Los Angeles, California.*

**My parents met in the civil rights movement. My father was a law student sent down to**
Mississippi by the Legal Defense Fund to work on desegregation cases. My mom was in
Mississippi registering voters and working with social welfare organizations connected to com-
munities and women in need. They met, fell in love, and were legally married in New York, since
interracial marriages were illegal in Mississippi. When they returned south, they were repeatedly
threatened by the Ku Klux Klan with cards saying they were coming to get us. I remember my
father with a rifle in his lap sitting on the porch with our dog, Andrew. Racism was, and is, alive
and well.

**When my parents divorced and the civil rights movement ebbed, I had to reckon with growing**
up in a fairly segregated world. My father moved to a predominantly white community, and my
mother moved to a predominantly black one. I went back and forth between the two. I grew up
most of my life not aware that my mother was "famous" or a celebrity. In fact, until I was fourteen
or fifteen, my mother, Alice Walker, was a writer and an artist—revered and respected by some
people, but not widely known and canonized as she was after *The Color Purple*. So, I grew up with
a woman who was devoted to her creative process and to realizing her life's work. She provided
that model for me as a young person and as a woman of color.

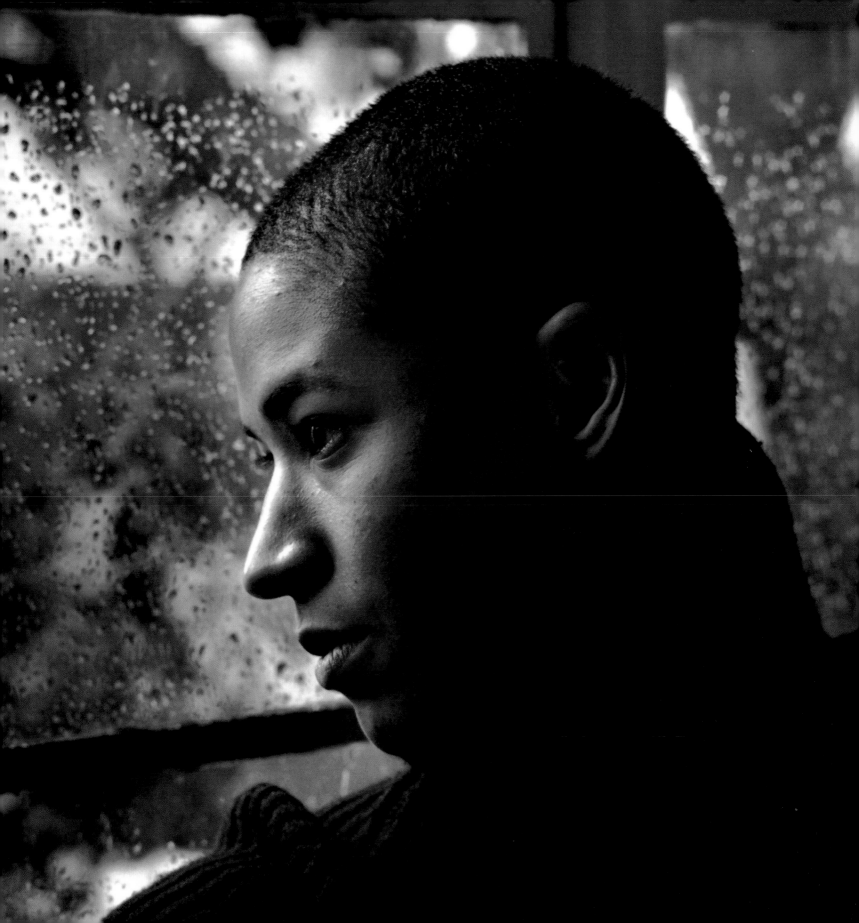

I think I came into my awareness of the reality of sexism and gender inequality in high school and college. While in college, I had an African literature class and the professor brought in the well-known and respected author Cyprian Ekwensi. I had noticed that in most of his books the women die in violent ways. I thought, maybe, in some way, it was a metaphor for the barrenness of the African soil. I wanted to know if it was symbolic. So I asked him. He immediately became defensive and told me that in his culture women didn't ask questions like that. Here we were at Yale University and he was telling me that I should not be asking him this question. When I told him I was disturbed by that, he said, "You must be a lesbian." My professor said nothing. Instead, he chuckled as if it was funny. No one in the class said anything. Meanwhile, I felt dismissed, violated, and unheard. My intellectual growth was not being facilitated by this discussion, and I ended up storming out of the room. That is an extreme example of the kind of sexism that I felt permeated my college culture, but it was not an isolated event. I experienced things like that to one degree or another throughout college.

Maybe because of it, I ended up doing a lot more fighting than I wanted to. Ideally, I would have been able to go to class and just have been able to learn, but as it was, I became involved in campus politics and speaking up in classes. It was part of my responsibility to myself, to my education, and to society. But sometimes I felt angry because I wanted to learn in that idyllic, no-worry environment just like everybody else. I wasn't able to because I was conscious of racism, sexism, and the ways in which language can silence and hurt.

3rd Wave was certainly the next level. The goal of the organization has been to encourage, inspire, and facilitate young women's leadership and activism. We do that through supporting different projects, leadership initiatives, and/or training, and through direct grants to women who are committed to their own development. It's thriving and the membership is way up. We now have chapters all over the country, each doing work on different issues. We started the organization in '92–'93 when we were graduating from college and into a really frightening political climate. There was a real feeling that there wasn't a young persons' organization voicing important issues. The NAACP and NOW were doing important work, but I didn't feel those organizations spoke for me. And at the time there was this media construction of young people being apathetic, apolitical, totally uninvolved, and cynical. I thought it would be important to harness some of the

energy, some of the anger and idealism of young people, and try to create something that could speak to what we were experiencing. I, and the others who started 3rd Wave, were committed to social justice and to making a difference in our communities.

It is interesting now when I go and speak on college campuses that there has been more scholarly work done on third-wave feminism, and my book, *To Be Real,* has received every kind of reaction. It has been soundly and roundly critiqued and it has been lauded. I love that it elicits so many responses and reactions. The book is about allowing people the room to look at their own contradictions and to look at the things in themselves that they are most afraid of. I think, in many ways, feminism was just a way to locate those deeper themes. It could just as well have been race that I was deconstructing with that book. But I had no idea I would speak at colleges across the country and have lines of young women and men come up and thank me so deeply for providing them with a link to something they recognized as an accurate reflection of how they thought and felt. You dream that your work can affect people, but I didn't know it would be such a specific kind of fit. The book is really saying that it's okay and necessary to challenge the status quo, no matter what the price.

It is such an arduous and difficult process to remain true to yourself and to the work you need to do. It gets more difficult when you decide to share yourself with another person and share your life with another person in their life. I am coparenting a child, and I am trying to be a responsible parent and a responsible artist. By responsible, I mean be true to the work I must do in order to feel as if I am paying my rent for being on the planet. Some days are great and filled with moments of ecstasy. But some moments are misery. As a student of Buddhism, I always remember the saying, "Ten thousand joys. Ten thousand sorrows." That seems to be how it all works.

# Rebecca Walker

# Crystal Hayling

Born June 2, 1964, Tallahassee, FL *Crystal's early family life was as dramatic and violent as they come. Around the time of her birth, both her parents were nearly killed by the Ku Klux Klan for their involvement in the civil rights movement. As a child being bused to school, she experienced more virulent racism firsthand. These early incidents have greatly influenced the decisions in her life—her dedication to altering society's acceptance of violence as an inevitable part of life, and her decision to go to China for a year in 1990, where she explored her racial and cultural sense of self as a teacher in Yale University's China program for recent graduates. Crystal is now the senior program officer and director of special projects at the California Health Care Foundation. She lives in Oakland, California.*

A couple of months before I was born, my mom was in the back of our house alone with my two sisters. She got up because she heard the dog run to the front. Something in her head told her to get down on the floor. So she did. At that moment the Ku Klux Klan shot up our house, killing our dog. My mom soon left St. Augustine for Tallahassee with my sisters to make sure I was born.

My father had been active in St. Augustine's civil rights movement. He was the youth leader of its NAACP branch. He organized people for nonviolent protest marches in this segregated town and was seen as the person who was instigating uprisings. But what he, and others, were really doing was trying to make some changes in their community. Right before, or after, I was born— I can't remember—he and three other men went to a Klan rally to take pictures of the license plates of cars parked for the rally. They were trying to prove that the people who were a part of the rally were, in fact, the same people who were chief of police, city council members, etcetera. Everybody knew this was true, but they wanted proof. They were caught, badly beaten, and had gasoline poured on them. The police decided to step in when everyone else was about to light them on fire. After that, it was time to leave St. Augustine for good.

After we left, my dad, being the break-down-the-barriers kind of guy, bought a house in Fort Lauderdale's white area, where we were the second black family to buy a home. I remember in fifth grade getting bused into the black neighborhood with all of the white kids. I sat low in my seat because it was so humiliating. Regularly, our bus was stoned and egged. It was a terrible feeling, but it certainly became something that was really important to me.

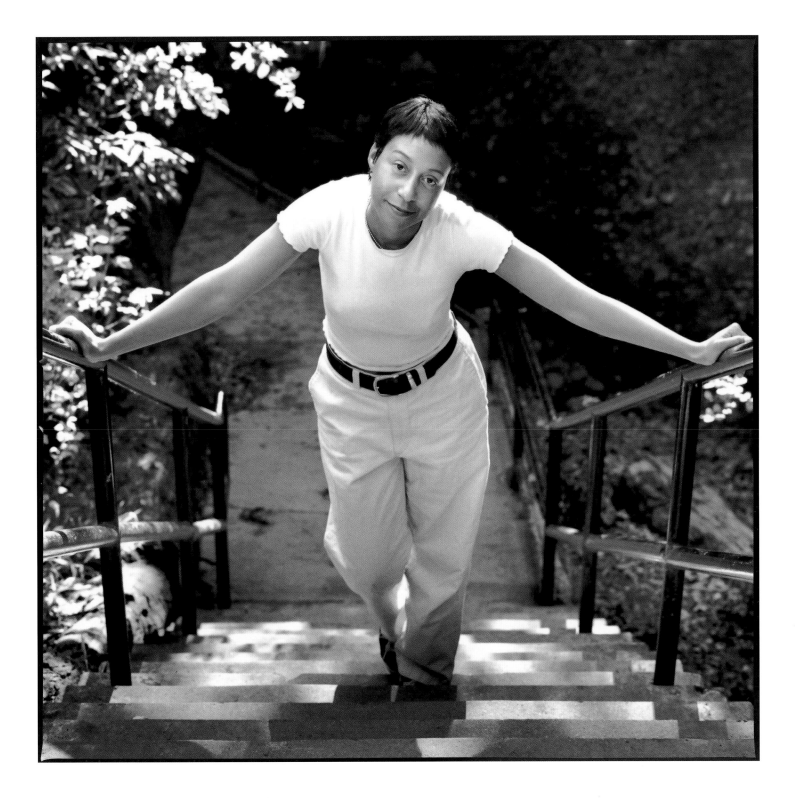

**That type of beginning has an effect on my life in some interesting ways. I once worked at a** startup health care foundation creating a violence prevention initiative. We were trying to get people to see violence as a public health issue. We were attempting to make them see how we allow ourselves to live in a society in which violence is an easy alternative, and to get them to see the long-term impact it has on not only the people who are the perpetrators, and the victims, but also the witnesses—the people who have to live with the memory of the violence. The young gang-bangers I talked to saw themselves as beating oppression through violence. Needless to say, we had a lot of interesting conversations about whether there were any positive uses of violence.

**The thing that is so striking about violence is that it is completely irrevocable. Many people** I talked with wanted to go back to the moment before the violence happened. We tried to get people to talk about violence as something that was not inevitable. Instead, we wanted them to talk about the many things one can do to avoid it: gun control, decreasing underage easy access to alcohol, which is consistently the drug most involved with violent crime, and how to direct oneself out of confrontation. There are preventative measures at all levels, and we stressed that observers of violence occasionally have tools and skills that will allow them to engage in its prevention as well.

**How I saw my blackness in relation to the violence in my family's history was one of the reasons** why I wanted to go to China in 1990. I wanted to find out what it would be like to live in a socialist society, but I also wanted to find out what it would be like to be a black minority where the majority of people weren't white. I wanted to know whether I would perceive my blackness differently. It turns out that I did. It's hard to have people stare at you and not think they are being hostile. It's hard to have kids run away from you and not think they are doing it because they're scared or they hate you. It could be that they hadn't seen people who looked like me. Maybe they were so excited that they were running to get their friends.

**Regardless, people treated me differently because I was in a program with other white people.** I appreciated the privileges I received, like heat, but as an American I felt completely at a loss for community because, outside of a few exceptions, the other foreigners who were there were colonialists who were insultingly deprecating and horrible to the Chinese people. It was hard because I had to spend a lot of time with those people and at the same time disassociate myself

from their behaviors. The racism I encountered in China against black people—though the Chinese have a reputation of not liking foreigners—was essentially learned from Europeans. The Chinese would say things to me that they had learned from other foreign teachers, like, "We're told all black people are poor." They were collecting ideas they had heard from other people.

Living in China allowed me to see that how I define myself is completely inseparable from my culture. No matter where you go, you are who you are because of your clan and your people. If you try and separate yourself from that, you're lost. But my clan changes depending on where I am at the moment. It could be a group of women, black people, or other people from Florida.

Right now, my clan is in Oakland and with the many smart people I'm working with. My goal is to make the health care system work better than it does now. There are many things wrong with it, and not just for extremely poor people, but for you and me. Increasingly we are all going to find ourselves in similar health care systems whether or not we are extremely poor or wealthy. It really matters to me how these systems function, and as with most things, a situation is only going to change if people go into it and make it change.

Crystal Hayling

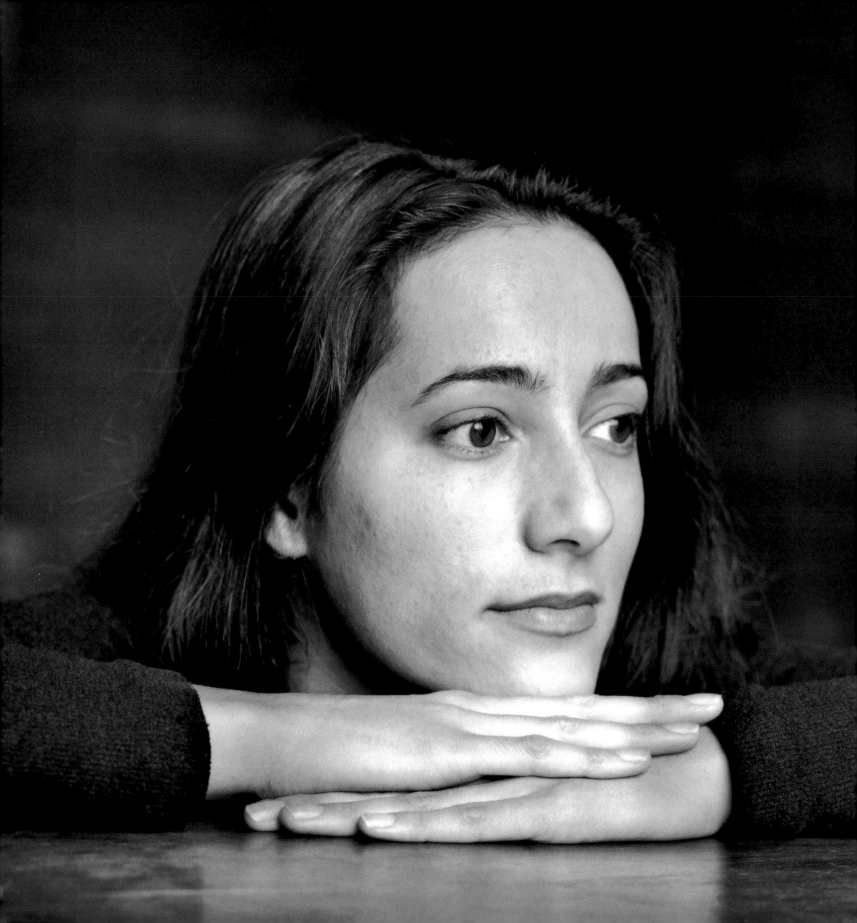

# Danzy Senna

Born September 13, 1970, Boston, MA      *Due to her fair skin, Danzy has often found herself in a position many of us have at one time or another wished to be in: the fly on the wall, privy to private conversations and candid perspectives. But, as I found out, we should be careful what we wish for. Her father's lineage is for the most part African American and Mexican, and her mother is from an old Massachusetts family, but Danzy's skin color is so light she is frequently mistaken for white, which has placed her in an endless stream of embarrassing and disheartening, yet educational and enlightening, situations. Her phenomenal first novel,* Caucasia, *published in 1998 and a National Book Club selection, describes a world in which race is the result of one's temporary locale instead of one's permanent skin color. She lives in New York City.*

Nobody can tell that I am black, and I have had to deal with that all of my life. My sister looks more black and my brother looks more ethnic than I do. Many people thought my mother had three children by three different men. My sister and I were inseparable. I did everything she did and copied everything she did. It makes so much sense for me to identify as black that it is hard to explain. I have a sister who was a year older than me, whom I was always with, and who was taken by the black world, so I naturally identified with her. There wasn't a question about me identifying as white. During the seventies in Boston, there wasn't any multiracial pride. You were either black or white.

Also my mother, who is this little, teeny, blond, white woman, raised us to identify as black. She is very political and not at all clueless about history. She was the one who would drive us to our Afrocentric school programs in the middle of Roxbury, Massachusetts. It's a strange irony but a lot of my politics and sense of self came from her. She raised us pretty much without any financial support from her family or my father. When she married my father she stepped outside of all of that privilege. We were on food stamps for years. She raised three black children by herself and instilled in all of us a clear sense of who we were. She is my heroine.

My other heroine, my sister, was much more accepted on face value at the Afrocentric school than I was. She was my protector there. The students and some of the teachers were cold to me. That is something I have a lot of anger about to this day. In Boston I didn't get the overt racism

18 | 19

that my sister did. It's weird because I have experienced racism in a sideways manner. The main way I have experienced it is through people saying things to me thinking that I am not black.

Eight months ago, I was at a dinner party in Los Angeles with a friend of mine who is white. Everyone else was white as well. At some point the conversation turned to a discussion of *them*, which I later realized was black people. There was a question like, "Do you live in a neighborhood with a lot of them?" And comments like, "How awful for you," "I work with a couple of them," and "Isn't it funny how they talk and the food that they eat?" These were writers and well-educated people. It has happened to me so many times that you would think I would be numb to it, but I was sitting there doing the same thing I always do: I listened for a while and I felt nauseated. Part of me is very humanistic and wants to believe that everyone is better than they seem, but I am constantly disappointed. So I said, "Can I just ask everyone a question? This conversation is really interesting to me because I am African American and I am writing a book right now. Is this how you usually talk when you think you're alone?" All these jaws just dropped. I was really upset with my friend because he had been silent while this was happening. When I started to say something, he did as well, but it brought home my feelings that white people don't respond to racism when they are offended by it. They expect that it is someone else's problem.

To counter these experiences, I have people in my life who have given me faith and humanity. Most of my friends are black, but I have friends of all different backgrounds and people whom I trust to give me faith. There have been certain black women in my life whom I have had tension with because of my skin color and my hair. But they are definitely the exception. I have gotten over my feelings of wanting to prove myself to black people. I don't feel the need, when I enter a party or an all-black setting, to make sure people know who I am. Now, I let the confusion and the nastiness happen because I think it is important to see who people are before they know who I am.

I went through my periods of trying to be *super black woman*. When I was in high school I wore bomber jackets, gold chains, and Adidas, and it was definitely racially linked for me. In college I took on this Afrocentric thing where I would always talk bitchily about black men who were with white women. It was indicative of my own self-hatred. Now I realize that that type of relationship doesn't take anything away from me.

I think it is more interesting to find out why people have this myth of race in their heads, and when I say I am black, what that means to them. Does it mean that I only date black men? Or, that I only do this, eat that, or drink this? When I say I am black it is a very personal thing, and I don't think you can define blackness.

In terms of being a woman, I don't believe in the *goddess*. One of the things my mother taught me about abuse of power is, "Whoever can, will." I have seen women do really bad things and men do really bad things, so I don't have a women's symbol around my neck. I am a feminist in the sense that I believe sexism exists and should be eradicated, but I don't romanticize the idea of *woman*. For each of us, being a woman is something different. The ability to give birth is the only thing that is deeply bonding for all women, and even with that, a lot of women choose not to become pregnant but are still genuinely women.

My writing encompasses all of this through story—making sense of the world and my experience in it. When I write there is not a split in my imagination and my experience. It is not at all a memoir. I wasn't interested in that. I was more interested in story and plot and character. I love writing and studying the world and creating stories. That is the thing that makes me happiest— not in the light sense of happy—but in the more fulfilled sense. I like the title of my first book, *Caucasia*, because it turns race into a place instead of a condition. For someone like the protagonist, Jessy, race is geography. It is a place where she stands at any given moment rather than a condition of her body. I feel as if I worked out a lot of my issues about race in the book, so that now I feel good about those issues. At one point in my life I thought there was something weird about me— that I looked white but identified as black. Today, it is my strength, and this perspective is a really powerful one.

I am doing what I want to be doing, and I am working toward becoming the person that I want to be. When you set off to write a book, you should write the book that you want to read. And that's what I did because the one I wanted to read wasn't in bookstores yet.

D a n z y   S e n n a

# Lanette Jimerson

Born August 17, 1974, San Leandro, CA *At age twenty-three, Lanette has lived a lifetime. Ever since her mother succumbed to a crack cocaine addiction when Lanette was still a child, it has fallen to her to care for her siblings. All through middle and high school, Lanette struggled to succeed in her classes as their living situation worsened and she and her mother continually fought. But she was determined to survive—and to make sure her two younger brothers did, too. When she was twenty-one, she took her mother to court to obtain legal custody of her youngest brother, and then she and her two younger siblings moved into a two-bedroom apartment together. Lanette has truly come out on the other side: she recently traveled to the University of Miami, where her brother, Charlton, was beginning his freshman year. When Lanette was seventeen, she received the National Black Women's Health Project's Women Who Dared Award, along with Anita Hill, Alice Walker, Angela Davis, and three other winners. Today, Lanette is a seventh-grade core teacher at Bret Harte Intermediate School. She lives in Oakland, California.*

22|23   I have four brothers: Derrell, Eugene, Charlton, and Terence. The first two are older and the last two are younger. Until I was eleven, my mom did a real good job of taking care of us. We lived in Oakland and always lived in nice houses. But then everything started to crumble. Terence, Sr., got my mom hooked on crack. She had done coke before because I remember looking through one of our windows and seeing white lines on the table. We moved to Hayward, California, and she started to use more crack as she and Terence, Sr., started to argue more. After he had hit her a couple of times, and me in the process, she eventually asked him to leave.

When he moved out she started using like crazy. The smell was so sickening. You know when they run the dry ice machine at a club and the room gets completely foggy? That's what the whole house would look like. Sometimes they would even use my room, and when I would go in later, my bed sheets and the entire room would be steeped in that smell. My mom started selling our appliances to the crack man. For us, he was like the ice cream man because he made a number of stops. There was only a little food in the house, and people were coming in and out of our house all night. The police came on a regular basis, and since I had an eighth-grade history class that started at 7:30 in the morning, I always faked that I was asleep when they came.

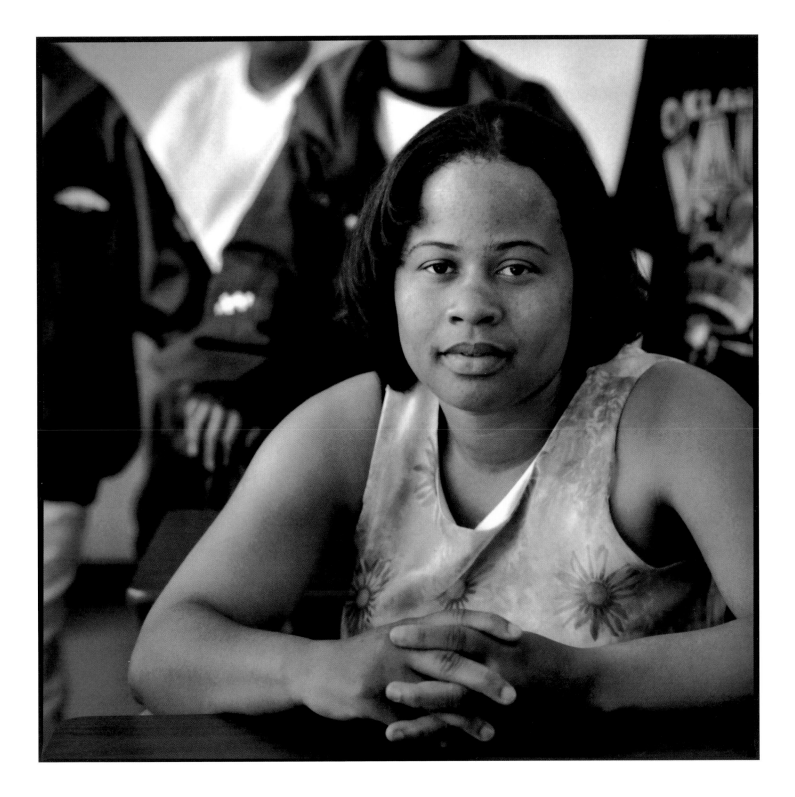

**My mom and I started getting in fights.** After she smoked all night, she would lie on the living room couch all day. We couldn't make any noise, and when I woke up for school she didn't even want to see my light shining. I lost my respect for her and started to talk back. Once, she slapped me and busted my lip. I turned to her and told her that was the last time she would ever hit me without me hitting her back. I started running away to avoid fighting with her.

**By this time, we were living in an apartment, and Derrell had been kicked out of the house for** refusing to buy my mother crack, while Eugene was in and out of juvenile hall for selling it. One day I ran away to an upstairs neighbor's apartment. In the middle of the night this woman woke me up to tell me that Charlton was yelling outside of his window. Apparently, my mom had exchanged drugs for sex and decided she didn't want to do the sex part. Charlton, who could not have been more than seven or eight, went into her room and chased the guy away with a knife. After that I decided that I wasn't going to run away anymore. I couldn't leave my younger brothers to deal with my mother.

**The previous summer I had gone to work at a summer camp and sent money home a couple of** times to pay the rent. When I returned, I bought my brothers' school clothes. We stayed in that apartment for a couple of months until we were evicted. After that we went to live in a crack apartment for two weeks until the manager kicked us out. I was still going to school, but I didn't get to class on time because I couldn't get up. I failed world history that year. I was pulled out so often by my mother to watch the baby that the school receptionist was very rude with me. Everyone whispered around me. But one day my eighth-grade teacher, Mrs. McBride, told me she didn't know what was going on in my house but she expected me to be in her class on time. She handed me an alarm clock and told me not to be late for her class again. I don't know if she really didn't have any idea what was going on, but something in the way she handled me made me feel okay. Her point was that no matter what was happening to me outside of school, I still needed to be alive in her class. And it was so important to her that she bought me an alarm clock. She is the reason why I am a teacher today.

When I was six I was often in trouble. Because my mom resented me for looking like my dad, I was always responsible for what went wrong in the house. I started taking my grandmother's medication to put myself to sleep when I was angry—whenever my mom would yell at me or hit me. Whenever she put hot peppers in my mouth, or would remind me that while she was pregnant with me she overdosed and my dad kicked her in the stomach. Whenever she told me she did all that she could to keep me alive, I would go into my room, open the drawer, chew one of my "rainbow" pills, and fall asleep sucking my thumb. Three years after I started doing this I took too many of the red ones. I still don't know what they were. I wasn't asleep and I wasn't awake but I couldn't get up. I lay in bed like that watching little imaginary white spiders on the wall for a day and a half. My mother didn't take me to the hospital, although she knew something was wrong. Once I came to, I wasn't allowed to even take a vitamin. In ninth grade, I began having dreams of suicide. I started messing up in school and became depressed. The family was falling apart and my mom was smoking more than ever. I refused to do a test, and my teacher, Ms. Carrai, sent me to a program, Youth in Transition, taught by the Independent Living Skills Program. While I was there I was able to talk about why I wanted to kill myself. She was another teacher who saved my life.

When I was a freshman in college, I took my mom to court to gain custody of Terence. My mom had decided she didn't want me to have him, so she fought me. Finally, she realized that if I didn't get him, she wasn't going to get him either. So she changed her mind. I got custody of Terence, asked Charlton, who was living with Derrell, to come and live with us, and the three of us moved into a two-bedroom apartment. I hate it when people say, "Wow, I can't even imagine doing what you did." You would do anything you thought you needed to do to survive. If surviving means that your two younger brothers survive as well, then you would do what it took as well. My father once told me that I was the mother of the family and I had to hold it together. He told me that it was just what I was supposed to do. That hurts. This was not my responsibility. I'm twenty-three. But today, I am a teacher with my own class, my students give me joy, and my house is so calm.

When I was seventeen and received the Women Who Dared Award, I didn't feel calm or worthy of receiving it. If I got it today, it would mean so much. It would validate everything I have ever done. It would allow people to know that not everybody who has been affected by crack fell apart. There are a lot of people out there like me who are taking care of their younger brothers and sisters. Those people can look at me and say, "I know that girl because I am her. It's good to know I'm not the only one."

# Lanette Jimerson

# Kathryn Busby

Born January 23, 1963, Brooklyn, NY      *In her current job as the senior develop-*
*ment executive for Universal Studios, Kathy is determined to improve the image of*
*African Americans and women on television. Change doesn't happen overnight, but*
*after meeting Kathy, you may begin to believe otherwise. Her confidence is contagious,*
*and even when she feels she is waging her campaign alone in a white male industry,*
*she refuses to be discouraged or disheartened. She won't quit until complex depictions*
*of African Americans and women fill the screen, enough to speak to the wide range of*
*human experience. She lives in Los Angeles, California.*

The person I am today is the same person I have been for quite a while. When I was turning thirty, I was writing and trying to figure out what this life meant to me. I realized I had been blessed with the vision of seeing the potential in everything—from the most ridiculous detail to the grandest scheme. I was born to enjoy this life in every possible way, and I have always known this world was mine to take and that I could do anything, go anywhere, and try anything. When those possibilities run out, I need to come up with more.

My parents came to America from Trinidad, a place where the ruling party has traditionally been black. To them, anything was possible, so they came here to the land of opportunity. I have always felt pretty lucky and privileged. Maybe, because of that, I have never come from a truly angry place. But I do get angry sometimes. For example, I just read a script for a television show that was another *Guess Who's Coming to Dinner*. That's to say it was about a black family moving into a white town and causing a lot of white people to freak out. What makes me angry about the script is that it's hanging a lantern on *black people coming*. You know what? We're here. We live here. This is our country. When I walk into a meeting, which in this business is mostly attended by white people, I don't want them to think, 'There is that black person." I want them to think, "There is Kathy Busby. She is the smartest person I have ever met." Or, "She has the best taste." Or, "She has such a fresh take on how we can work with this sitcom."

Recently, in one of these meetings we were talking about the potential of related merchandising for a show popular with a black audience. Somebody in the meeting said, "Merchandising is a great idea because those people are going to spend their last dollar on a shirt." Racism

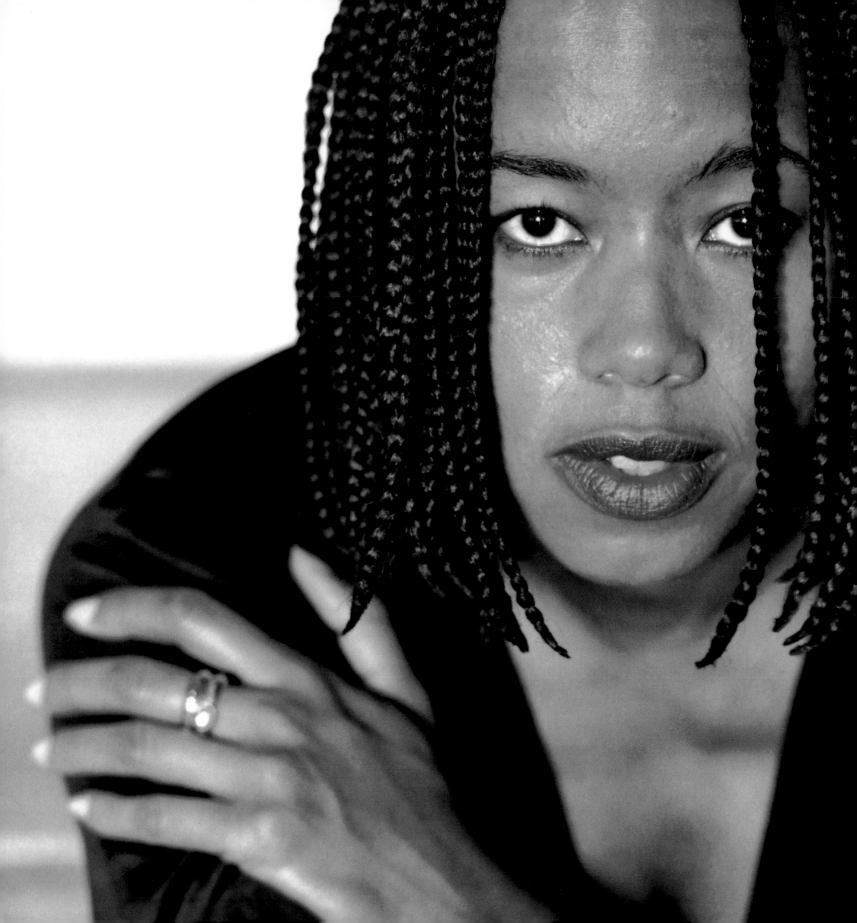

happens. Another example occurred when we were casting a show about two brothers. One is a little crazy and neurotic, and I suggested to one of the producers to make them black. He said, "No, we can't make them black because that would change the show. We're not black writers and we can't write to that experience. This guy is neurotic." Believe it or not, I said, "Wait a minute. Black people can be neurotic, too." It may seem like a crazy thing to defend, but many people, blacks included, think there is one way to be black, and anything else is acting white. What does that mean? It is almost as if we as black people were so abused and destroyed when we came to this country that our black identity has become everything that is not white. So, if white people want to have a lot of money, be successful, and have an education, we have to pursue the opposite to be authentically black. Unfortunately, these images do come from both sides. But I can do anything—I mean anything—and it doesn't matter if black people like to do it or if white people like to do it. It is only a question of whether I want to do it.

When I had an interview for my current job, I met with the president of the studios and he asked me why I wanted to be here. "Why television?" I told him I wanted to improve the imagery of both black people and women on television. He added, "And white men." I disagreed with him and told him that white men didn't need my help on television or anywhere else. That's what I intended to do when I came here and, hopefully, what I am doing now. There are so many ways to do it. If the star of a show is black, it doesn't mean all of her coworkers have to be black. That's especially true when you look at the country and see that we are only 12 percent of the population. That's okay. But you know what? If there is only one black character, he can also be the best, she can be the star, we can be the smartest, the best-looking, the kindest, or the most stable. That is what I want to do. That is what I want to develop.

It is definitely an uphill battle because many of the "black" shows already being aired are doing a disservice to that goal. The shows are very one-note. It is fine to have that one note just as long as there are shows with thirteen other notes to choose from. And, it is true, many of them are created by black people, but not by this black person. Until I see me on television, then television will not have done me a service, only a disservice. That "me" character could be completely mixed up, nutty, or unmarried. Most likely, she would be a character who really believes this world is hers for the taking and takes it. She won't just aspire to take it but she will actually take it.

Once, I had a job interview and the interviewer asked me how old I was. With hesitation, I said twenty-eight. He said, "That is a great age." When I asked him why, he said, "Because that is the age that you are." Somehow, in that moment, I just accepted his philosophy that anywhere I was, and anything I did, was the best that I could possibly be because that's where I was. That philosophy has defined me for the last seven years. Maybe it even defined me before and I just didn't realize it.

Kathryn Busby

# Angela Singleton

Born November 22, 1967, Atlanta, GA      *Angela was only two years old when her mother died in a car accident. Though she now sees this loss as a defining characteristic of her life, when she was growing up she focused most of her energy on taking care of her father, who was at the time a functional alcoholic. Being "motherless" affects the way that Angela walks the world, but she gleans inspiration from as many sources as she can. She works as a marketing representative for the Peachtree Athletic Club in Atlanta. She lives in Decatur, Georgia.*

**I remember in kindergarten drawing a family tree, and I didn't draw the mother arm branch.** When my teacher asked me why, I told her in a matter-of-fact manner that my mother had died. She thought I was lying and sent me to the principal. It was so out of her psyche to even think that someone didn't have a mother. I took that to mean that it wasn't normal, that it wasn't a good thing, and that it was something that I needed to hide. So I did.

**I grew up stoic. No one in my family ever discussed my father's alcoholism. In fact, we didn't** really call it that until I was about sixteen years old. He went to the hospital with something unrelated and suffered withdrawal. He was one of those functional alcoholics who could pick me up after school, make dinner every day, and do the things that he was supposed to do. But we still had to help him off of the couch and put him to bed. I learned to keep secrets fairly early in my life.

**I had always seen my mother's death in terms of my father, that is, my father losing his wife.** Never until much later did I see it as something that was personal to me. I had decided that it was my responsibility to be a good kid, cause him very little anguish, and do pretty much what he wanted me to do. I think because I was the baby, the appeaser, and the placater, I was terrified for years that my father would also go away and not come back. So when he went out of the house, I would be his car buddy. Whenever he went somewhere, I was always the kid who wanted to be there with him. Retrospectively, I wasn't living truthfully. I was doing whatever I needed to do to get what I wanted, which was my father's approval, attention, and the guarantee that he would stay.

**Looking back on it I wouldn't say that my mother's death was torturous or even tumultuous.** Because she died at such an early stage of my life—and this is not to romanticize our relationship—

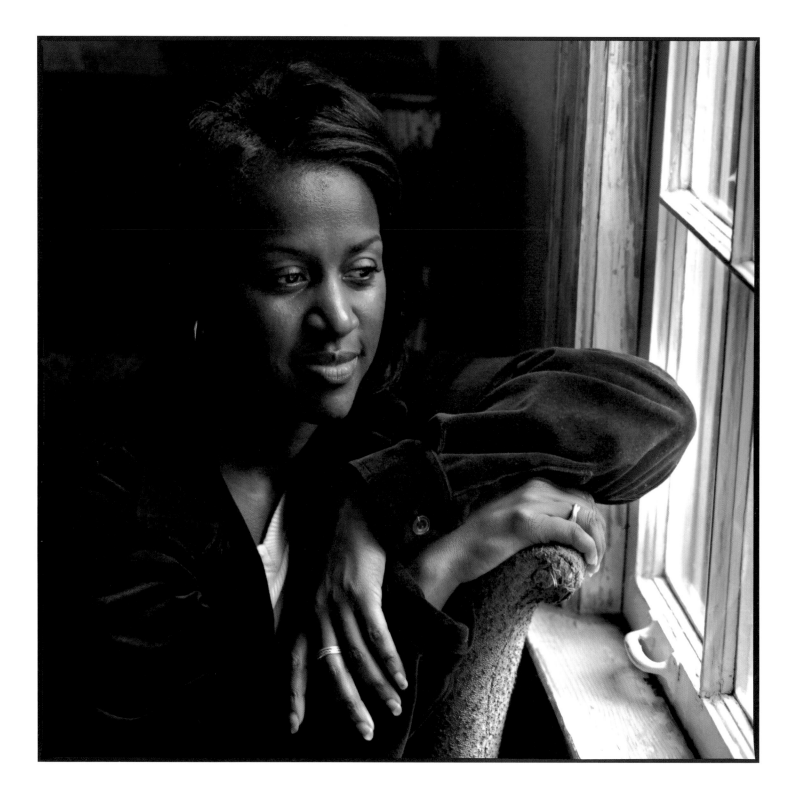

it has become the most defining moment of my life. It had such a profound effect because at that stage in my development my personality was so malleable. It caused me to expand into an openness that today I sometimes still struggle to reconcile with the world. Normally a small, prekindergarten child's world is pretty myopic. My world immediately had to expand past that so I could reconcile myself with a world that I saw, in which everybody in it was intrinsically different from me. Even my father had a mother. I will always have to deal with being "motherless." I always have to overcome feeling a little alienated and incomplete because of that lack, and it is something I can never be compensated for.

**But my father gave me my appreciation of literature, which exposed me to cultures and different** types of people. He encouraged my violin playing and appreciation of music. I feel like he gave me a good base. I went out and did most of this work on my own, but he certainly gave me my space to do it. My mother's death gave me an ability to cope with many different situations and a flexibility with life.

**My openness is constantly challenged. The first time I really felt my ethnicity was when I was** fifteen and working at an amusement park, Six Flags Over Georgia. I was working as a little foreman in attractions when one day I saw this belligerent black man being escorted out in handcuffs. When I looked at him I felt as if my heart had stopped. I became so personally involved with this guy that I went home and spoke with my father about it, and I said, "Dad, I have the feeling that had he been white it wouldn't have impacted me in the same way, but I don't know why." And he said, "Well, you know that when people are looking at him they are judging you." For years after that I thought that I had to carry my entire ethnicity on my back, and it was my job and my job alone to show white America our differences were only visual.

**I remember Shelby Steele saying in** *The Content of Our Character* **something about black culture** being formed in oppression rather than freedom. Approaching an integrated room, or a room that is predominantly white, I know that before I open my mouth there may be judgments and generalizations about me before any of my character and personality comes out. There is nothing I can do about it. That gives anybody an intrinsic insecurity that is hard to transcend. Let's say it happens before you walk into an interview. You have to get past other stuff that the white culture doesn't even have to think about. They just have to think about getting through the interview.

I know a woman who had a name that seemed ethnic, and she actually changed her name on résumés. Only after she went into the interview would she tell them her true name. She felt they would not consider her because of the name. I feel like I have always had to transcend the color of my skin. Someone is going to have to have a conversation with me before they know who I am. I don't look like the girl who snowboards or wakeboards, but I do. They are both very important parts of my life.

## Angela Singleton

# Maia Garrison

Born March 6, 1967, New York, NY          *Maia is the daughter of renowned Jazz bassist Jimmy Garrison, John Coltrane's collaborator for seven years, and Roberta Escamilla Garrison, an Irish-Mexican dancer and choreographer. As a child, Maia performed with The Big Apple Circus for two years, but shortly after her father's death when she was nine years old, Maia's family moved to Italy for ten years. After attending Sarah Lawrence College here in the United States, and dancing with Urban Bush Women in 1995, she started her own dance company that same year, M'zawa Danz, which explores African-derived dance styles. She lives in Brooklyn, New York.*

Independent, creative, intelligent, and strong women have always been in my life. Women in the arts like Ntozake Shange, who were doing their own thing, were friends of my mother's. They would often come to the house. I saw my mother, a dancer/choreographer herself, run her own company for ten years in Italy. I worked with Urban Bush Women and saw how things worked there. I have been pulling dancers together and doing pieces since I was in college and have often been in positions where I have had to be in charge. Having my own company was a natural place for me to go, and I had no fear of tackling the job.

Before I joined Urban Bush Women, I had been developing a dance style of contemporary, modern, traditional, West African, and hip-hop. After I graduated from Sarah Lawrence College, I created a solo performance that I immediately performed in a variety of venues. I got some attention from that. The style has become my company, and we are rooted in West African dance. A lot of contemporary modern dance creates movement and vocabulary rooted in ballet. It is a very Eurocentric style of dance. The way I work is to create dance styles with West African dance or an African-derived vocabulary at its basis. I say derived because there are so many of them: Afro-Cuban, Afro-Brazilian, Afro-Caribbean, hip-hop, and street dances. Everything I come up with has that African movement form in its roots. When I choose women for the company or different pieces I put together, I look for women who have those styles in their body.

The style is important to me because it comes out of my body more naturally than any other. It's much more exciting for me to dance that way. People of African descent relate more to movements of that nature. I have this theory that it is because of our ancestral memory. I was clearly not a part of the African American community growing up in Italy for ten years. When I first

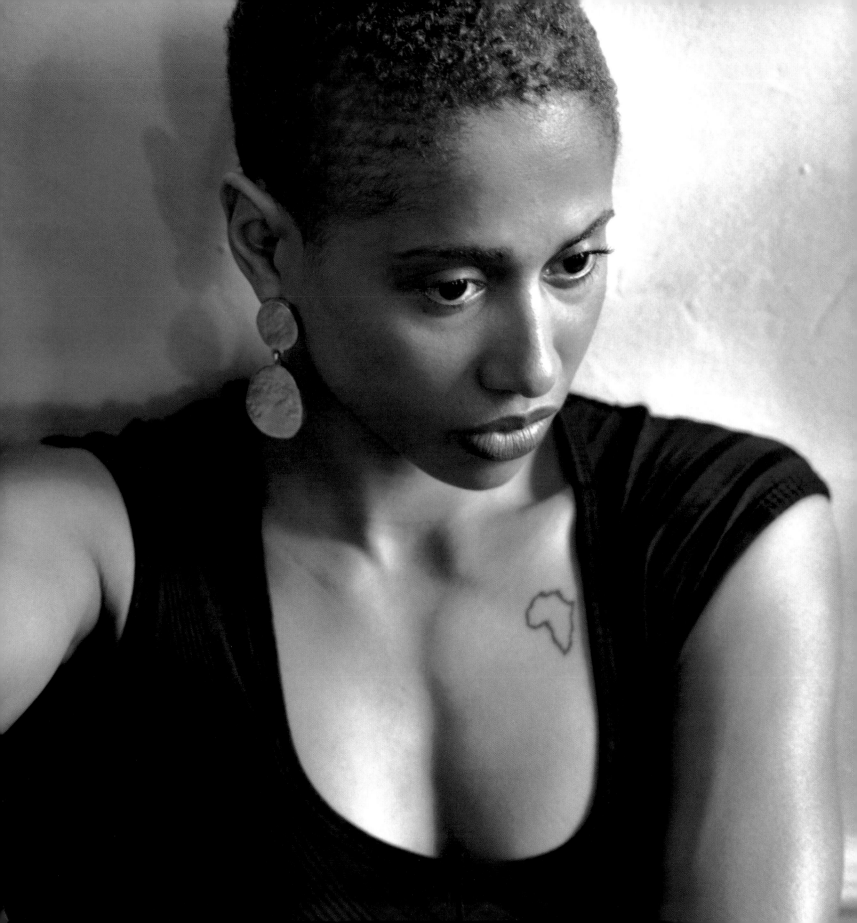

started dancing in Italy, I was dancing modern dance and watching my mother, who also does contemporary modern dance. When I came over to the States, that's when I immersed myself in African-derived dances. At first I had a hard time. I couldn't really do it. But it didn't take long to get. Maybe in the first month of studying all of these styles, it just came to me. It clicked, as if I had done it before.

But the company is more than dance styles. It's a business, and I often have to speak to presenters who consider signing performers. A lot of them are men who may listen to what I'm saying, but at the same time, they're checking me out. I have had to deal with men who will tell me they'll help me with my work only if they get a little more from me. Sometimes it's straight up and not subtle at all. Some decide they have fallen in love with me and start calling, wanting to wine and dine me. I remind them that I want a working relationship and that's it. The truth is a few working possibilities have fallen through because I have said no. Then, they turn around and say they can't work with me. Men are men. I understand that they can meet a woman and be attracted to her. But I think they always want to see if there is a possibility for that other level. Some of them are respectful, so when I tell them I'm not going there, they understand and back off. But others have said things like, "Well, I can't be around you because you turn me on, and I am going to want to go there with you if we have a working relationship."

Even with that stuff, it is worth it because I am making these dances for my people. I feel connected to the African-world community. Unfortunately, there is concern in the company that if we cater to black people, we might not get work. I am certainly not closing the doors on white people. If they want to come to a performance, that's great. They *should* want to come in. But I am doing this for my people because we need to educate ourselves and feed our souls. Those are the people I am getting the most love from. They are the people who really relate to what I'm doing. Black people are loving it.

I am serious about what I do, and one thing that really changed my life was finding out that my dad was serious about what he did as well. I have very few memories of him and even those are vague. Recently, I was talking to someone who happened to work at a jazz radio station. He told me they had an interview with my father from the seventies in their archives. He sent it to me immediately. When I sat down to listen to the tape, it was as if I had met my father for the first

time. It was deep. It was cool because not only was I hearing his voice and how he expressed himself but also I was hearing him talk about his work. And the way he talked about his work was the same way I talk about mine, even though my thing is dance.

They say he revolutionized the way the upright bass was played. He was into flamenco music and flamenco guitar and tried to do flamenco guitar on the upright bass. He was the first person to do that. He would do a lot of percussive stuff on the bow—rather than just playing the bow back and forth, he played it like a drum. He was considered innovative in what he was doing. So of course I identify with that because that is what I'm trying to do. I'm trying to take something to another level. Hearing him talk made me think, "Well, my dad did it, so I *really* need to do it." It was a major inspiration for me to hear that interview, and it gives me a sense that dancing is my duty. I have to do what I am doing, and if I don't, I'm being irresponsible.

# Maia Garrison

# Candace Weekly

Born December 16, 1967, East Oakland, CA     *Candace has always wanted to be different. When she graduated from the California Culinary Academy, she knew that her determination to follow her talents—even though they were different from those of most of the people she knew and had been raised with—had paid off. She is now a pastry chef specializing in wedding cakes with true-to-life flowers, for which she's received national acclaim. She lives with her partner, Mark, in San Francisco, California.*

I see myself as a black woman, and I don't make it an issue, but in this business I notice it becomes very obvious that I am black. The wedding cake business is one dominated by white women. It bothers me that the white women see me as a novelty and that black women are not sure of me. A couple of times after I have introduced myself, they immediately have said, "You're Candace? Hmm." Why should the color of my skin make a difference to somebody? I'm human and I'm creative.

As a black woman in this business I feel like I have to be better than everyone else, and I don't think I would have that pressure if I was white. I have to be more polished, more professional, and more punctual just to prove that I can do the job. I don't believe in talking about race all of the time, but I know it is what people see. That adds pressure and makes me crazy. It really does. For example, I know I cannot be late. I've got to get there on time because being late is one of the things that black people are known for.

In fact, I have always wanted to be different. I have always believed that if you want to attract attention to yourself, you have to be different. It works. But it's not so much a desire to be different as it is to be seen and respected as a mature woman. There is something beautiful about older women. I do not understand why older women are just hung out to dry in this society when they reach a certain age. I don't understand these men who have to have a silly twenty-five-year-old when they have this beautiful mature forty-something-year-old woman. Women get better as they get older. They age gracefully. I'm looking forward to it.

At the same time, however, the Generation X crowd just doesn't get respect, but I don't know if we deserve it or not. I know that I respect myself and that I deserve respect because I really care about people—especially the ones that I work for. I want to make sure that I respect the choice they are making and don't hurt their feelings. Every morning I get out of bed knowing that people like my work. Not so much that they like me—although a lot of them do—but my work. In this very personalized industry, the fact that they are relying on me and trusting me with their special day tells me that I can't let them down. Believe it or not, some brides don't care about the dress, and they don't care about the flowers. All they care about is the cake. Since it is the last thing, the cake can make or break a wedding. If it's disappointing, their whole day is ruined.

Before I went to high school, I told myself that I would be a pastry chef. My mom was like, "Oh, okay." My teachers thought that I would be able to do other things. But even though I said that I wanted to do it, I really didn't believe that I could. I have always had this interest in baking, and I have always been really good at it. It was on the back burner for a long time, but when I graduated from the California Culinary Academy, I remember thinking, "Wow, I actually did something I said I wanted to do." I couldn't believe it.

Now I am in the wedding business making cakes, and it is exciting, but I know that I am doing something that you don't see a lot of black people doing. I hope more black women—in fact, not just black women but black men as well—enter this industry. You don't often see black chefs outside of ethnic foods like soul food. As a matter of fact, there is a collective of black chefs in Sonoma, California, that I didn't know about until recently.

As black people, we need to set higher expectations for ourselves. Too often, we have low expectations, thinking that we can't do this or that. It becomes something that we pass down to our children, "Black people don't do that." It all goes back to constantly hearing "we can't do it." We have proved that we can do anything. When I saw Debi Thomas skate, that drove our ability home to me. I thought, 'Yeah, we can do anything." We have just been told that we can't, but we can. Now it needs to extend to other fields.

Before graduating from the sixth grade, we were getting all of the commencement ceremonies assembled and the school put together a little booklet of things that the students wanted to be. All of these kids were saying they wanted to be a model, or a doctor, or a lawyer. All of the usual

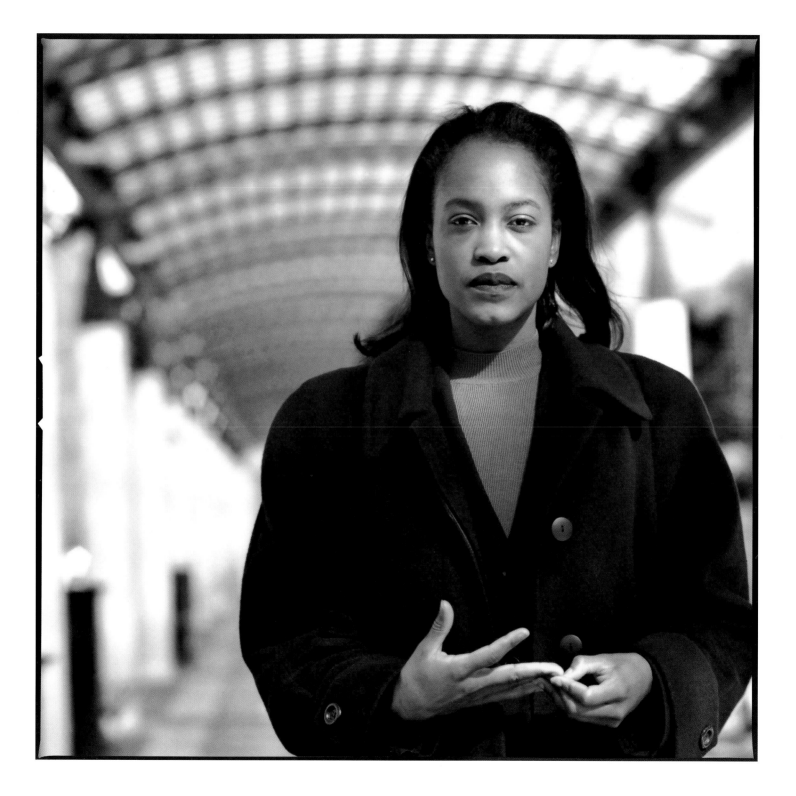

things you hear. I put "me." The teacher came to me and said, "I saw what you wanted to be when you grow up and I don't understand." I told her that what I wrote was what I meant. I just wanted to be me. Let's face it, I didn't know what the hell that meant, but I just wanted to be different. So now I have become who I am and it is definitely different.

## Candace Weekly

# Yvette Bonaparte Thor

Born May 5, 1968, New York, NY

*Profound self-hatred and a lack of self-esteem as a teenager led Yvette to years of escape through alcohol. After achieving sobriety in 1990, she rediscovered her love of writing fiction and entered the masters in creative writing program at San Francisco State University, which she completed in 1997. Her first short story was published that same year in the magazine* Writing for Our Lives. *Recently, she took a trip around the world, which bolstered her understanding of her heritage and ethnicity. Yvette is currently working on her first novel and expecting her first child with her husband, Leifer. They live in Oahu, Hawaii.*

My husband, Leifer, and I just returned from a trip to London, Greece, Egypt, India, Nepal, and Thailand. Time after time, and place after place, I was stared at because of my skin color. Trekking in Nepal, I was stared at, but it was because they were intrigued. In Egypt, it was because I was a beautiful, black woman with dark skin. In Thailand, it was because they had never seen anyone with hair like mine. The most hostile experience came in Greece. When I walked down the street, I felt eyes on me. When I turned to look, whoever was in the café would stop in midsentence and stare at me. I got it from people of all ages, and from men and women. One time, eight- or nine-year-old kids taunted, jeered, made faces, and pretended to be scared of me. Even though they spoke Greek, I didn't need a translator. The strange thing is that it was August, and the beaches were packed with people all trying to become my color.

In Egypt, covered up, solemn, Muslim women broke into huge smiles and said, "Hello, Nubian!" as I walked past. Ordinary strangers, men and women, would say, "Hello, cousin." After a while, I said to myself, "I could get used to this." I felt revered. A seventeen-year-old boy who took us on a *felucca* [small boat] across the Nile told Leifer, who is white, how lucky he was to have a black woman for a wife. He said that if he had a son, he hoped he would be as dark as me because he'd get all the girls at school. That perception of my skin is the opposite of what I get in America and what I got in Greece. They were telling me the color of my skin was perfect. They were telling me they wanted their kids to be my color.

Understanding that would have been a huge challenge for me when I was younger. In fact, ever since I was a teenager my greatest challenge has been confronting my fears. Living and not being afraid to live. I just wanted to check out all the time, and I did it with alcohol. I grew up in a

white neighborhood, and except for the maids who came in to clean the apartments, my mom, dad, and I were the only black people living in our apartment building. In the laundry room, white tenants would come up to me and say, "Who do you work for? You're doing such a great job."

Growing up like that and going to a high school where I was one of five black kids in a school of six hundred, I always felt like I didn't fit in. Not to blame it all on race, but it was a significant part of why I drank. I wanted to be more a part of the white kids around me. After graduating from college, I started every morning with brandy in my coffee. I would drive to the ferry smoking a joint, get on the ferry to New York, drink on my lunch hour, and try and make it through the day. I always wished that I had a flask, but I never got one. I would go back home on the ferry, finish the joint I had started in the morning, and stop at the liquor store on the way home and pick up either a bottle of vodka or beer, but vodka got me drunk quicker so I would buy that. I would drink maybe three-quarters of the bottle and black out. It wasn't like I drank because I liked the taste of alcohol. I hated the taste of beer. I hated wine. I liked champagne, but I wasn't drinking it because it tasted good. I was drinking because I wanted to get drunk. And if you are drinking to get drunk, chances are you probably have a problem.

In June of 1990 I confronted another fear: staying sober. I had to learn how to live differently, to not compare myself to everyone, and to realize that I was okay the way I was. I was blessed. In the first six months or so, I was relieved of the obsession to drink. It became easier because I had help through meetings with other people in recovery, and we all shared our experiences, our hopes, and our strengths with each other. I learned that with six months of sobriety I could help someone with two months of sobriety because I had been sober longer.

Three weeks after I got sober, I cut off all of my hair. My hair had been straightened since I was eight years old, but after my haircut I couldn't hide anymore. Cutting it off exposed me. My forehead, my ears, my scalp, and my neck were just out there. I became more confident and comfortable with my body, my hair, and my skin. I became more comfortable with my heritage.

When I got sober, I had to get honest, and I had to believe in a higher power. I used to think people who believed in God were phonies. Before I would have thought, "Shit, what is she talking about? Pray for me? I don't need anybody praying for me." My God became a lot like Sarah Vaughan. She was how I wanted my God to look. She smoked, which was perfect because back then I smoked. She had the blues, and I imagined her cradling me.

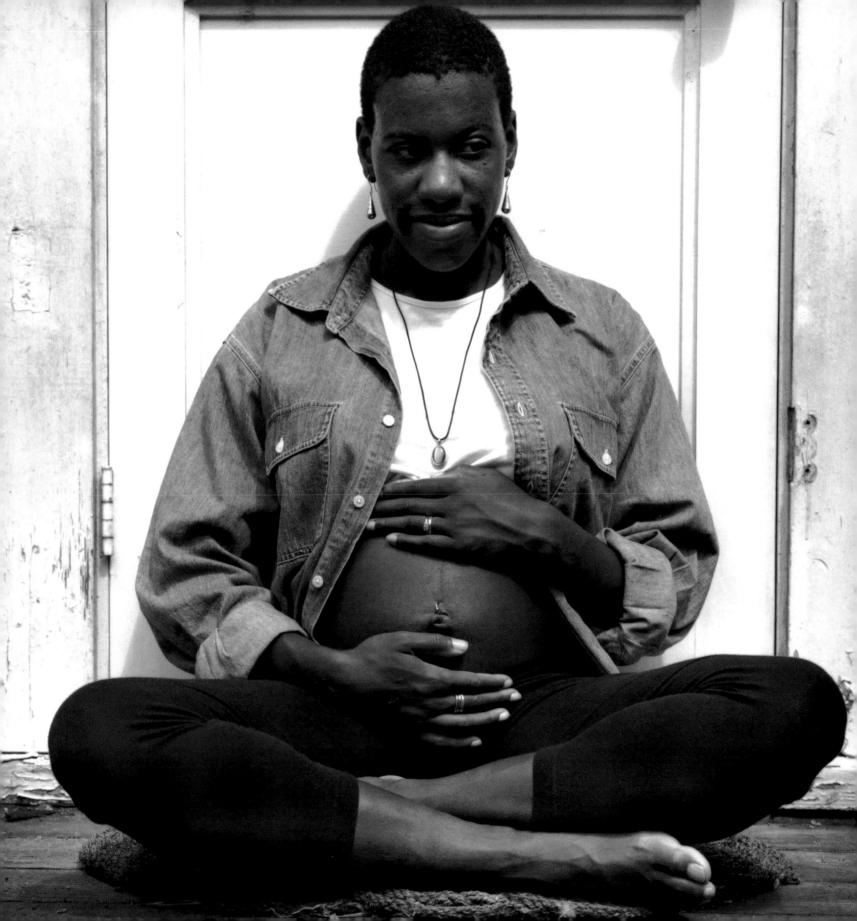

**That's when I noticed that writing had a more significant place in my life. I had always written.** I was six or seven when my mom was working on the dissertation for her Ph.D., and to keep me out of her hair, she would sit me down with a legal pad and ask me to write her a story about the nearby George Washington Bridge. I used to think that I needed to be a lawyer, or a doctor, or something, but on the side I always wrote. It wasn't until I was four years sober that I started thinking that writing could be my thing, and it didn't have to remain on the side. I had friends like Stephanie Moore who were writers. She told me, "Don't just let your writing sit. Get it out. You are not just writing for your teacher, you are writing to be published." She was such an inspiration to me. With her help the first piece I sent out, "Fun House Mirrors," was published in a journal called *Writing for Our Lives*.

**As I get older, I am getting more into who I am supposed to be. My life, my values, how I see** myself in the world are lining up. I feel like there is more for me to do here. I am expecting my first baby in September, and my faith is getting stronger because I am calmer. I don't worry as much anymore. We have a saying in recovery, "God didn't save me from drowning to beat me to death on the beach." When bad things happen they are now just another growth experience. I know I will get through it, and when I do I will be such hot shit.

Yvette Bonaparte Thor

# Farai Chideya

Born July 26, 1969, Baltimore, MD          *The daughter of an African American woman and a Zimbabwean father, Farai has developed a deep understanding of the complexity of her background. She brings that unique insight and comprehension of cultures to her job as a correspondent for* ABC World News Weekend *and* Good Morning America. *Previously with* CNN *and* Newsweek, *she has found time between reports to write two novels,* Don't Believe the Hype *(1995) and* The Color of America *(1998). She lives in New York City.*

I have always lived in the States, but I visited Zimbabwe when I was five and continue to do so today. The country is very much a blend of modern and traditional. Harare, the capital, looks just like any other city. It could be Cincinnati except that everyone is black. Overall, it's just a place with real people, real problems, and real happiness. Some of Africa's problems are much more severe and intractable, but the basic reality is that except in certain war-torn countries—and they are by no means the majority—people get up, live, get married, all that stuff. I always thought of it as a place where people *lived* as opposed to a mythic homeland or the cesspool of the planet.

Even though my parents came from different cultures, I truly believe my mother never thought of divorce when she got married. But that's what happened. To not think of divorce almost seems unthinkable because there are so many people my age who are not planning on getting divorced but at least have that fear on their minds. My mother was, as much as was possible, the mother and the father to my sister and me. We did it all with her. The term "single mother" has been completely demonized, and it does mean different things to different people, but there are some women who choose to raise kids alone who do a great job. Some women choose to do it and do a horrible job. The same is true for married parents. The reality is—especially in the black community—many people are raised by a single parent. We should probably try and drop that number, but we should also try to make sure that single parents have support.

My mother has always been an inspiration to me. In fact, I have always had strong, black role models. Most of the people who have supported me have been black. But I have had black people

who have definitely not supported me, and I have had white people who have supported me. Race, in general, is about patterns. Specifically, it is about the pattern that blacks are discriminated against by whites. But in my personal experience there is less of a blanket pattern where a whole group treats me this way or that way. Individual people have helped me or individual people have tried to hurt me. Maybe my experience is different than others because I have always been—as much as I have struggled—in a relatively privileged position. I have been working in places like *Newsweek*, CNN, and ABC. And even though there is all sorts of drama no matter how high you get up the totem pole, I have never been as vulnerable as most black people are in the workplace. Many have little recourse.

My position has taken me from celebrities to politics. I have done education. I have done print and television. People used to think I was flaky or flighty, or that I didn't know what I wanted. Maybe that's true. I don't think there is anything wrong with not knowing or not having a five-year plan as long as you do a good job. I am the kind of person who sees life as a series of branches where you move forward and then you can go this way or that way. You pick one direction, then you move forward again. Some people see life as the shortest distance between two points, or as a straight line. I am not like that, but I do know there are things, like writing books, that I would like to continue doing.

My first book, *Don't Believe the Hype*, details how blacks are portrayed by the media and how the statistical realities of African American life are completely different than those passed on to the public. The second book, *The Color of America*, looks at race through the eyes of people in their teens and twenties and is a chance to examine the assumption that a more multicultural America would mean an America in decline. It pokes holes in that particularly offensive theory.

An accurate look at the statistics shows us that for violent crimes blacks get 50 percent more jail time than whites, are more likely to be convicted, are disproportionately punished for the crimes they commit, and sometimes convicted for those they don't commit. As America becomes more black and brown, you are only going to divide the two groups further over time if you have one group getting one type of justice and one set of job opportunities, and you have another group getting another kind of justice and another set of job opportunities.

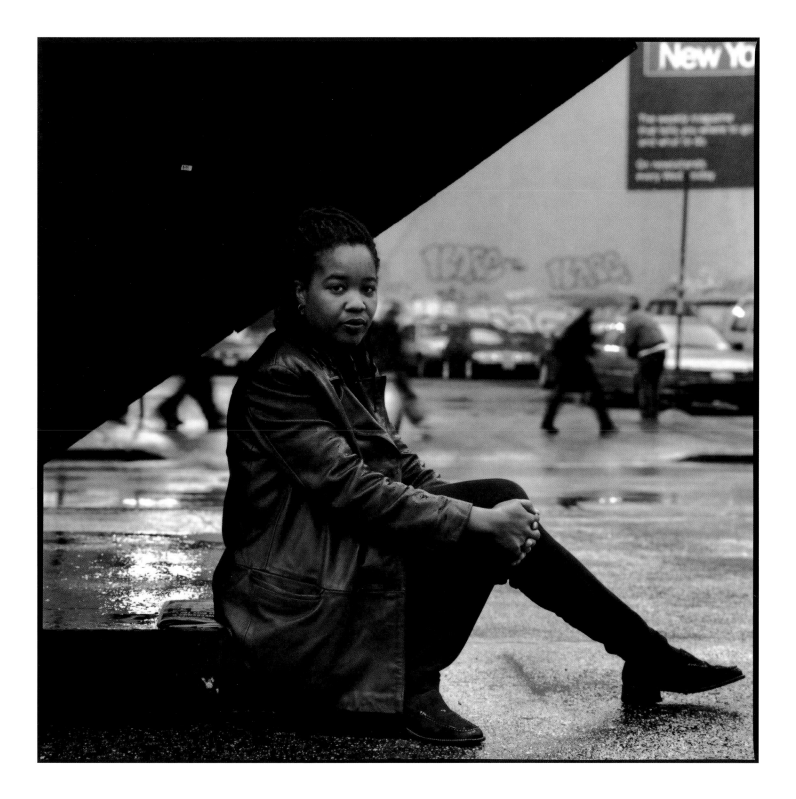

One of my arguments in the second book is that we are in this backlash against racial diversity when we should be in a fighting position against inequality. We are spending more time talking about dismantling the few remedies we have for discrimination than we are talking about creating new ones. The argument in *The Bell Curve* is that Head Start doesn't work because the kids are stupid. Of course, Head Start works and the kids aren't stupid. The problem is that you have kids who have received a good preschool education because Head Start has allowed them to build self-knowledge and self-confidence. But once they are thrown into substandard elementary schools, those gains evaporate. These kids are not stupid. They only need a chance to continue the learning process they were exposed to in preschool.

As a television news correspondent, I *am* a watchdog for the images of black people. The reality is that I have to be. I can ignore it or I can fix it. When people say, "Black journalists spend so much time dealing with racism," my response is, "If we don't, who will?" I'm not going to deny I spend a lot of time thinking, writing, and reporting on race because it is necessary. I don't think it is anything I have to apologize for. But I do think that you have to strike a balance. I'm interested in music, pop culture, and politics, and I like to switch back and forth between the different worlds that I cover. It's a great job, but it is also the kind of thing where everything is too deep or everything is too shallow. The worst part of being a journalist is that you always want just a little more.

Sometimes, however, you can take a simple story to a more complex place. A few years ago, I was reading this snippy neoconservative article in the *New Republic* about black neighborhoods in decline. The language was something like, "For some unknown reason when black people move into a neighborhood, it declines." I was thinking that it was such b.s., and I mentioned to someone that I wished there was something called the Black Person's Reply Book, so anytime someone said something stupid you could just open it up and say, well on page fifty-seven… This person I was speaking to, who wasn't black and wasn't on top of black issues, said, "Wait. That's a good idea." He had a point, so I found out about the ways in which "white flight" helps

erode the economic base of neighborhoods, and if I had known them at the time, I would have sent a letter to the *New Republic*. I simply became tired of people talking trash and not really knowing what they were talking about. So I wrote my response to their ignorance, and that response became my second book, *Don't Believe the Hype*.

Farai Chideya

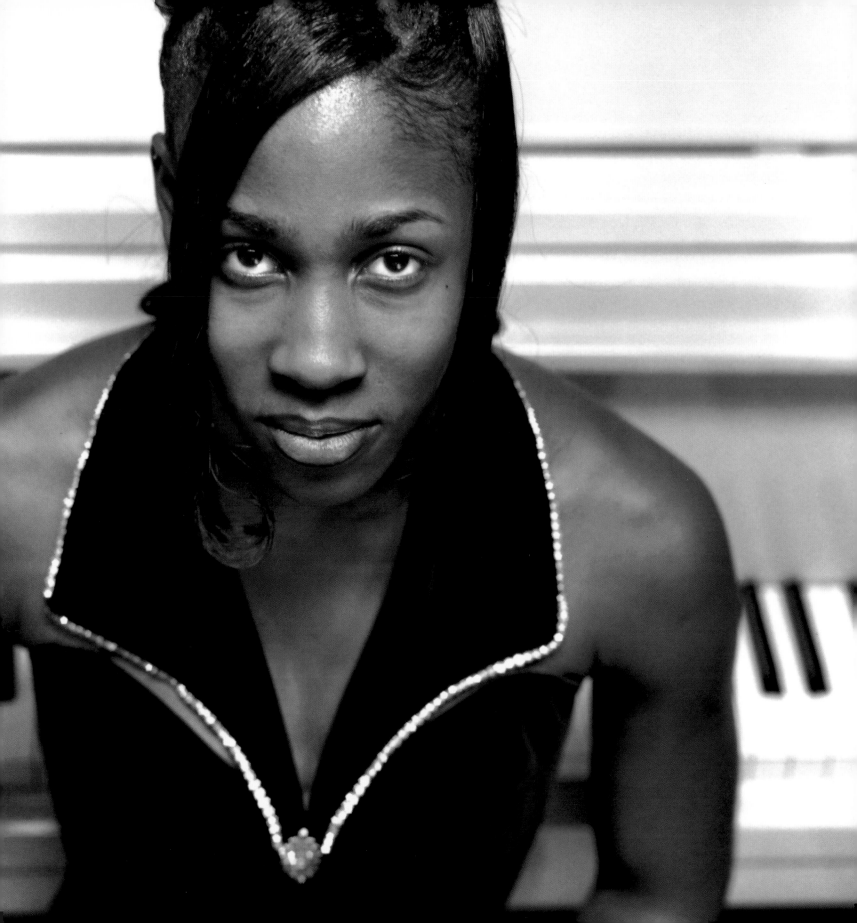

# Dana Morgan

Born May 9, 1980, Warren, OH  *At a young age, Dana has taken on many challenges. She realizes that to become a classical pianist of some stature she must sacrifice a lifestyle that many teenagers consider a right. She graduated from Warren G. Harding High School as a member of the National Honor Society in 1998, but endured criticism from her peers from spending countless hours practicing and studying. Her dedication paid off in 1997 when she performed in front of a large audience at Showtime at the Apollo, a nationally televised variety show for amateur performers. At each venue and recital, Dana feels she represents the potential of youth, regardless of ethnicity. But more than that, Dana wants to succeed as a classical pianist because she loves the music, which soothes and comforts her soul. She lives with her mother, Gwen, and father, David, in Warren, Ohio.*

My mother noticed that I had long fingers, and she had always wanted a baby girl to play the piano for her. So she signed me up for Suzuki, a course where if you know your letters up to G and your numbers up to eight, you can start beginning classes in piano. That's how I got started. I probably was like any other child, but my mother says that she noticed something different, even though I still couldn't really tell you what it is. As I became older I grew to love and appreciate playing.

A lot of my black peers don't understand why I have such a love for classical music. Because of the style, there are not too many black people my age and in my high school who are into that kind of music. They can be discouraging, and some think I am trying to be better than them because I don't party all the time. Most of the time I am so busy with music that I don't get a chance to go to parties and social events. Some of it is jealousy and some of it is a lack of understanding for what I am doing. Even though my peers may not like the music, they can learn to appreciate it by appreciating the genius of the composer. They can appreciate it knowing that someone composed thousands of symphonies and orchestras all in his head. When you think about it, all music is tied together. You will find classical music in all different forms of music.

Focusing on my music allowed me to play *Showtime at the Apollo*. It was an experience of a lifetime. Usually I work from the energy of the audience, but that was one time that I had to block out everything and everyone. I knew the audience was accustomed to hip-hop and bluesy jazz.

So when I came out, and they announced that I would be playing Etude in C minor by Chopin, I started getting nervous. I saw the reaction on their faces, and it was like they were asking the question, "She's playing what?" But I am glad that I got through it without having the sandman come and escort me out. They gave me a handclap because they knew that I had some kind of training.

Sometimes when I am playing in front of an audience, I feel as if I am playing just for me. Then sometimes I can send a message that not all young people, black or white, are doing something bad, but that there are many of us who are trying. When I play I am representing young people in general. I don't make it a black-white issue. There is so much time and energy spent talking about what young people aren't doing instead of appreciating the young people who are doing something. There is too much time spent criticizing. Because of that we don't get to the root of the problem, and teens don't develop self-love.

The biggest problem facing young people today is a lack of respect for themselves and a lack of respect for other people. We don't have respect for our parents, teachers, and elders. If we can have respect for who people are, what they are, and what they have been through, we will be better off.

My ultimate goal is to become a great, versatile pianist who happens to be a phenomenal African American woman. I will achieve that by getting all the training and experience that I can get. Even if I don't achieve that level, I will be happy knowing I tried. When I was younger, there were a lot of times when I would have rather played with Barbie dolls than go to music class. Sometimes young people need to have a driving force give them that extra push when they need it. My driving forces were my parents. Getting a push plays a part, but you also have to want it for yourself because nobody can force you to want it.

To be a phenomenal black woman means that I have to be strong because I know that I am going to have a whole lot of hurdles to cross over. I am going to have to be mentally, physically, and emotionally strong because I know that I will have to go through a lot of trials and tribulations to get there. I know that I need knowledge, a spiritual relationship, and a sense of humor to get there.

If I am having a great day and I wanted something to express that, I would play Haydn's sonata in D major. If it was a sad day, Rachmaninoff and his prelude in G minor. If I'm upset and I want to calm down, I listen to Debussy. If my day has made me mad, again I play Rachmaninoff. It is like a release. I can hear the strings and feel as if I am playing with an orchestra. I feel the things I went through that day and how they affected me. My emotions become a whirlwind of feelings coming together in a storm. It's similar to the confusion of an orchestra tuning up before they start to play. To me, when I am playing a deep minor song, I am thinking about confusion and chaos and wind and thunder and rain. I am thinking of everything that is loud and annoying, together.

Music has always been a part of my life. I really can't see my life without it. It fills in the many colors of a monotonous picture. It is that certain something that I need when I'm feeling bad because there is a song to make me feel better. If you are having a great day, there is a song to allow you to express that joy. There is always going to be music for an occasion that feeds your soul.

Dana Morgan

# Sonya Owens

Born October 5, 1967, Queens, NY          *It's a rare person who can spot a trend and develop a good idea to take advantage of it, but it's a rarer person still with the moxie to pull it off. Sonya is one of them. When she was younger, she sold clothes to her mother's hair salon clients as a creative way to make money. As hip-hop music and fashion grew in New York, she realized there were lots of other places that wanted these fashions but didn't have access to them. So she decided—despite the many obstacles facing African American businesswomen today—to move to Atlanta and open her own clothing store, Mack's Cab Company, which sells men's and women's casual sportswear with a focus on urban lines and designers. She lives in Decatur, Georgia.*

I think it does take a village to raise a child. If a parent doesn't have a family to help her with the duties, it will be tough. My mother had my grandmother. When my mother went to work, my grandmother, or my aunt, or someone else would look after us. Everybody had a hand in raising us. This is what I saw. Maybe because of that I never did without. My mother and my grandmother made sure of that. They are my two role models. My mother used to own two hair salons. She is responsible and knew that bills had to be paid on time. I saw her handling all of that while raising two kids. Kids are impressionable, so what you see is hopefully what you become. I feel like I am just like her. Today, I'm the businesswoman.

I used to sell clothes out of my trunk when I lived in New York. I would go to the garment district to buy, and then I would give some of the clothes to my mother for her to take to work. I sold clothes to my girlfriends and to the women over at the hair salon. Then I noticed hip-hop was taking off, and since I had traveled so much, I saw there was a need for these types of clothes in places other than New York. So I decided to move down here in 1995, and I opened up this store.

It has been great and it has been a challenge. The first negative experience I had was from these good ol' boys who let me know I was not supposed to be running a business. Their first problem with me was that I was a woman, and their second was that I was a black woman. Once, I sat down with a contractor and a designer for a meeting. I was telling the contractor what I wanted, but when he started talking he directed every word to the designer, who was a man. He didn't even acknowledge me. He didn't care that I was the owner because there was a man there.

Even though I would ask the question, he continued to respond to the other man in the room. He was paying me no mind. The only thing he said to me the entire time was "Hi." He never once acknowledged me as a businesswoman. By the way, the designer was black, but he was a man. So I told him to come with me because we were getting out of there. I didn't want to deal with that contractor. Outside, the designer reminded me where I was setting up business. This is a place full of good ol' boys, and I get it all the time. The people down here think I am so hard because I am not the little, sweet woman at home like I am supposed to be. But I know the way I am is just how I have to be in business.

In fact, once I had someone working for me who hated me for no reason. He had a problem with a woman being in control. Sometimes when I have to say something to the people who work for me, they will argue with me only because I am a woman. If I was a man, I would hear none of that. At some point, I decided these men would have to respect me for who I was, and if they couldn't, I didn't need to do business with them because I am the one writing the checks. That was it.

I am learning so much from this business, and it was only from what I learned at every job I have ever had that allowed me to be here. People don't realize that the smallest thing, like working at a retail clothing store and ringing up the cash register, may have an impact on your life in ten years. Everything you do up until the day you find the thing that you love holds weight as an experience. It will come into play. Working at banks in every position from a teller to an underwriter has helped me in this business. Working at Alexander's in a shopping mall has helped me. Working at a supermarket has helped me. I was a bookkeeper there and counted out everyone's register and approved money. It was more knowledge under my belt, and I do the same thing now at my store.

I was able to open Mack's Cab Company because I ask questions. I will drain someone's brain. I didn't know the fine details of this business, but I had a girlfriend who was in it, and I called her every five minutes to ask her what something meant, or what I should tell someone who was coming in for a meeting. And she would tell me.

I have a lot of people in my life who have been supportive. People like my mother, who would give her arm if I called and said, "Mom, I need your arm." And people who have let me know

that it was okay if I failed. But we never fail. We just might have to get up and try something else. They have given me that cushion in case it doesn't work. If it comes to a point where I have to bail out, it's okay because I have friends who are behind me. If everybody had those kinds of people in their lives, they wouldn't be afraid to do things. I wasn't scared to take everything I had and put it into this company because I knew my mother and my friends would be there for me. So it's okay. It also helped that I put God first.

Sonya Owens

# Meri Danquah

Born July 21, 1968, London, England    *Meri and her family came to the United States from Ghana when she was six. The ensuing years brought a series of challenges and hardships and began her battle with clinical depression, a debilitating medical condition. With the support and help of friends, and the determination to live a life her daughter would be proud of, she has been able to understand her depression for what it is and to take measures to overcome it. Her first book,* Willow Weep for Me: A Black Woman's Journey through Depression *(1998), is a memoir of her struggle. Meri's second book,* Becoming American: Personal Essays by First Generation Immigrant Writers, *is under contract with Hyperion publishers. In June of 1999 she will receive her masters of fine arts in writing and literature from the Bennington Graduate Writing Program. She lives in Los Angeles, California.*

I started feeling depressed when I was fourteen probably because a lot of hard things have happened in my life. I was sexually abused as a child, and I experienced adjustment problems for a couple of years at boarding school. People would tell me, "You always seem so sad." I just thought it was me because teenagers are thought to be miserable people. But it was something clinical. The depression would lift, and afterward I would go through another episode of it. Then that would lift and I went through another. Even after it had lifted, I would still have a low-grade clinical depression.

The feeling I had was an overwhelming sense of hopelessness, and all I ever wanted to do was open a blank book and write what I felt inside. Whether it was a story I created to help me escape my current reality or a presentation of that reality, that is all I wanted to do. I wrote *Willow Weep for Me* because I wanted to have a dialogue with other people. You just can't walk up to somebody on the street and say, "Hey, how is your Prozac treating you?" Later, when I understood the depression, I would go to support groups—and this is still true today—and be the only person of color there. I was suffering from clinical depression, and I felt as if I was the only black person in the world dealing with it. It's true that even within the white community there is still a stigma attached to depression, but even with the stigma there is more openness, more dialogue, and more sharing. How are we supposed to survive if we live in a community where we can't ask for help?

**When I moved to Los Angeles, I started attending acting and writing workshops. I felt whole** inside of literature and around people who were communicating with the written word. I was a different me. I didn't feel optimistic, but I felt understood and I felt that my pain was being assuaged and identified with. The workshops were a more acceptable place for people to hear about the type of pain I was trying to convey. When I sat down to hear their honesty and their pain, it made me realize there was no other space in my life where that existed.

**Then, one day I got up really late. I took a walk to get my coffee and freaked out. It seemed as if** I could hear every noise around me. I would see a shirt that was really bright and have a sensory overload because of it. People were laughing all around me. It was like I was on a merry-go-round and I was spinning around and around. I had a panic attack and ran back to the house. I did not come out for three weeks. With each day something about me deteriorated. After a while I would wake up and stare at the ceiling. I started thinking that I had to die because I was this horrible person who didn't deserve to live, was nothing, and would make nothing of her life. I was convinced nobody cared about me and I had to die. I would have killed myself if I'd had enough energy, but I couldn't get out of bed. [Laughs] That's the truth, and it's true of a lot of people who are depressed.

**Then one day the telephone rang—I had turned it back on maybe a day earlier—and I answered** it. My friend told me she had gone to Berlin and brought back a piece of the Berlin Wall. I had been so shut off from the world that I didn't know the Berlin Wall had come down. The whole world had gone on without me. In that moment I knew I had lost my mind. I knew something had happened to me. I thought, "Well, it happened and I'm back. It's not going to happen again because I'm going to be really careful and really sure that I'm on top of things."

**Of course, it happened again—in fact, within weeks. And it happened again after that. After it** didn't reoccur for a period of months, I was so ecstatic that I felt ready to have someone to take care of me, and I entered into what turned out to be a horribly abusive relationship that resulted in my pregnancy, and now, my daughter, Korama. After I gave birth to her and started going through another depression, a friend told me about his mother, who had been dealing with clinical depression for over thirty years through electroshock treatment and medication. He made it clear to me that I was also clinically depressed. It was also clear that when I made the choice to

have Korama, I needed to do everything within my power to make sure she would not experience some of the things I experienced. That meant that I would have to be the person I wanted her to be. I had to look at my life differently. Look at my relationships differently. I had to start looking at myself as a victim differently. I had to laugh.

And today I am doing it. I am teaching her love. I am teaching her to believe she has a right to love, to safety, and to happiness. I believe just letting her know she has a right, period, is the bottom line. Whether you're black, Asian, or a woman, every group has their own way of feeling victimized or done wrong. Often, women are taught that love and violence can go hand in hand from the same person. But the bottom line is claiming your right to be who you are. The freedoms we have today are a result of people's claiming them and fighting for them. I want my daughter to know that no one has the right to take any of those freedoms away.

Meri Danquah

# Ayodele Embry

Born August 22, 1974, Lexington, KY *A strong spiritual faith and the love and commitment of her parents have inspired Ayodele to pursue her talent and her passion, engineering. She graduated from Georgia Tech with a bachelor of science degree in electrical engineering in 1996. That same year she was selected for USA Today's All-USA Collegiate Academic First Team and was the National Society of Black Engineers Member of the Year. She is now enrolled at Stanford University to pursue her masters in the same field. Her first name means "joy comes at the break of day." She lives in Palo Alto, California.*

Truthfully, my faith in God and my family tie in very closely. I believe God gave me my family and because of that I must do whatever I can for them. At the same time he gave me talents and a family that was supportive, therefore I would be letting God and my family down if I didn't use all of my talents to the best of my ability. That's why I work so hard at my studies. I first learned about engineering from my aunt. She is an engineer, and when I was a child, she was working for IBM in Lexington, Kentucky. Because she lived at our house while she was co-oping [working while you are enrolled in school], at a very young age my brothers and I got to hear what a real engineer did. It was the combination of making stuff with a focus on math and science that made me interested. I have always liked to create things, and I have always liked math and science. Over the years I started developing other skills and began to think that electrical engineering was something that I really wanted to do.

In my family it was an unspoken rule that you were to get good grades, and if you dropped from an A to a B, my parents wanted to know why. If that happened, they would ask us if we needed to get a tutor. They didn't let it drop several grades before they got concerned. My father used to give us reading assignments during the summer or Christmas breaks. We would have to read books, or write them, or write poetry. Education was more than what we did at school. It was worked into everything.

If you are proud of who you are and where you come from, it makes you more sure of your abilities. You don't have those nagging questions in the back of your mind, like "Can I do this?" Instead, you develop the understanding that people have been studying engineering, math, and the sciences for years. You don't have the belief that because you are an African American student, and

you don't see those role models out there, then you're not sure that you can do it. I may not see those role models in front of me, but because of my history I learned to be very proud of what people could do if they wanted to.

I fell in love with Atlanta when I went to Georgia Tech, and in 1995 I became Miss Georgia Tech. The honor was a testament to my accomplishments. It was as if my peers recognized me and said, "We think you are doing good things. We appreciate it and think you deserve this." It was also a recognition that I was smart but had another dimension. I can win awards for academics, but I can also win awards for things that have nothing to do with academics. Georgia Tech breeds that in you. Most of the cool students who were doing really well in school were the same people who were running the organizations, and the same people who were at the parties every weekend.

When I was in school I realized that it was the perfect place for me to hone my talents, open my world, see and experience different things, and meet different people. When I left I said to myself that I couldn't imagine having been anywhere else in that point of my career. Now I am here at Stanford—a completely different environment—and I feel as if this is where I need to be. My support system is here, and there are a lot of things I want to do, and if I take care of my formal education now, it will be so much easier to do those things later.

I have chosen the one discipline in engineering, electrical, that has the lowest number of females. My entering class this year includes 250 electrical engineering students. I think only 50 of them are females. Of the 55 that are black, I am the only female. But I never play the game of letting someone, no matter what their race or gender, think they have the upper hand just so that they will feel better about themselves. No, I am highly intelligent and they know it, so they will have to get over it.

I am excited about engineering. I think being excited is a challenge facing young students heading into the field today. Teachers must get students excited about math and science and excited about their futures. I volunteered for an organization in college that hosted high school students overnight and talked to them about engineering in college. We visited their high schools and worked college fairs. I told them they could do anything they wanted to and that it was just a matter of preparing themselves for it. Once, in college I had a student come up to me after class and tell me I was the first person who ever told him directly that he could do anything he wanted to.

I was the first person to tell him he could go to college if he wanted to go. No one had ever just looked at him and said, "Yes, you can go to college." That hit me so hard. In my heart I felt like we really were doing some good by coming out here, talking to these students and being role models. We have to go back and be an example for them and say, "Hey, you can do this because I have done it."

There is nothing more gratifying than the personal satisfaction of seeing what you do really make a difference. You can't see it right away, but several years down the road when someone comes and says that you influenced them, that keeps you going and makes you all the more willing to go back and work even harder the next time.

Ayodele Embry

# Heather Hiles

Born December 11, 1968, Hollywood, CA        *Heather's lineage can be traced back to the union between Sally Hemmings and Thomas Jefferson, so making an impact on society seems to be in her roots. As president of San Francisco Works, a city-sponsored program created to guide welfare recipients back to work, she is doing just that. She is putting into practice what she learned as an undergraduate public policy student at the University of California at Berkeley and as a Corel Fellow, which introduced her to the various sectors of city public affairs. She lives with her partner, Melinda, and their son, Cole, in San Francisco, California.*

Technically, if you were to dissect the genetics of my blood, you would find that I am more white than anything else. The mixture on my father's side is pretty clearly mixed, and my mother's side is predominantly German. But I consider myself African American because, in part, that is the culture I have been exposed to, and, in part, in this society if you are part black, then you are black.

My mother and I spent a year and a half in Malibu, California, before we moved to Crenshaw. In that neighborhood she was one of the few white people I remember seeing. I was treated differently from her, but she is very strong and was not the kind of person who would take a lot of crap. When I was a child she would drag me to her ACLU meetings. Her independence and strength gave me my cues for what it means to be a girl. I didn't have a lot of pressure about maintaining the traditional roles of a girl. I played basketball and went to the Olympic Development League, and it was a good thing because it made me feel more comfortable and positive about my height. In general, playing basketball gave me the structure in my life that I desperately needed. When I look back on my childhood I see that my attraction to strong women as lovers, friends, and otherwise comes from that conflict of what it is to be a girl and a woman.

I use that structure today in my new job. With the passage of the New Responsibility Act, people have five years to use welfare money before they are kicked off. They will be without resources if they don't find some skills or learn how to maintain a job. I think the private sector here in San Francisco recognizes that they will have to pay the toll of people who aren't going to be grant recipients anymore. They recognize economic costs as one of their motivations for wanting to participate in this program.

This is an extreme and pessimistic perspective, but if there is a significant population who doesn't have access to any resources to survive except from what they can beg, borrow, or steal, then they will impact those who do have resources. You can imagine how that will take place. They will end up in prison, dead, or in some other nonproductive setting. No matter which pool of resources you get aid from—whether it be taxes or what you have to give away in charitable contributions—it will be a draw on society. There are also the opportunity costs of people who aren't being productive and contributing to the American economy. I think welfare has always been the Achilles' heel of our country because there is a huge opportunity cost we are not addressing. We need to look at the long-term costs as well as the immediate costs.

I have always been interested in public policy, but I realized by the end of my undergraduate work that I didn't want to be an analyst and I didn't want to develop abstract policy. I think it's best to understand public policy from an implementation perspective, from where the rubber meets the road.

After graduating from the University of California at Berkeley, I did a Corel Fellowship in public affairs. It is really an amazing program because you have an internship rotation in all the sectors of public policy. I worked at the Government Affairs Department at Chevron—even though I had majored in development studies, which means I studied how multinational corporations impacted developing countries. So, to be in a multinational corporation that did have a lot of global impact was pretty ironic.

The place we are born into is random, so if you are lucky enough to have privilege and resources, then you need to figure out how to help other people who haven't been born into that position. Walking in so many different worlds and interacting with so many different people helped me to understand that. Part of that equation is class and race. They are so intertwined in this country that it is hard for me to imagine that race could be neutralized. However, even though socioeconomic status can be impacted by race, socioeconomic status is probably the biggest hurdle we have to face. But I don't think you can throw race out of the discourse because there is so much prejudice and racism in this country.

My love, Melinda, is from Canada. And when I try to describe to her the significance of race in this country, I don't think she truly understands because race means something different in Canada than it does in the United States. It does not have the same level of importance, nor is it the foundation of the history of the country as it is here. Just think, I have never met a black person who has not felt racism. Never. Race impacts everything in the U.S., and I know that it is not just whites that have to get past racism. So many times I have been around a sorority sister, or someone else who is black, who said something derogatory about white people. We are all impacted negatively by racism, and it has a lasting effect.

Our son, Cole, is part Cherokee but he looks white. When people see me with him, they always assume that I am his nanny or something else. If Melinda and I are together we notice how people always talk to her, or ask me questions that make it clear they don't believe I am the mother. When I think about Cole, I can see him having a different awareness of what race means than other white men. He'll have more awareness—seeing how his mother is treated—than he would if he didn't have anyone black in his life.

Heather Hiles

# Kesha Weekes

Born July 17, 1975, Limestone, ME *Many of us question our direction in life, and whether we are living by our deepest convictions, but it takes real courage to follow through and begin doing so, especially if you are only a freshman in college. After facing this question, Kesha decided to become a missionary, and today she is part of the Rejoice in Jesus Campus Fellowship outreach program at Stanford University— her alma mater. Somehow she also finds time to tutor at the East Palo Alto Tennis and Tutoring (EPATT) program, which fosters academic and athletic development of youths, aged six to eighteen, and their families in East Palo Alto, California, where she also lives.*

I have always been interested in politics. It started with me wanting to know why as a country we let certain things happen. For example, how we allow people to be hungry; as a politician I could find the answers. But then I realized it was impractical. The hands of a politician are tied. They become disabled by the influences of factors that drive the system. I ended up taking public policy courses in college to look into the process of how policies are formed. Even though I didn't find the answer to why people remain hungry, I was able to understand how institutions can impact the policy. I now have fewer questions, but I still don't have the big answers. The courses were enlightening and made me understand how I could function in that system and manipulate it just like anybody else. Because of the classes, I decided to have a more hands-on approach at the local level.

When I was in school, it dawned on me that I was on my own and had to make a decision about the direction of my life. By the middle of my freshman year I felt torn. I wasn't really living the life of the person I was supposed to be. I kept asking the same questions: What is the purpose of my life? What is my direction? I was being pulled in different directions. I needed to know what was *the* direction. One weekend I locked my door and I didn't let anybody in. I had to make a decision. Was I going to live my life for myself and to please other people, or was I going to live it for the Lord? I always had a fear of God, but I didn't live as if I did. I remember thinking just how boring it was going to be if I lived my life for the Lord. Even with those fears, I knew inside that what I was currently doing was not all that there was. I was running here and there and keeping myself busy, but there was the feeling that there must be something else. I didn't have peace and I didn't have rest.

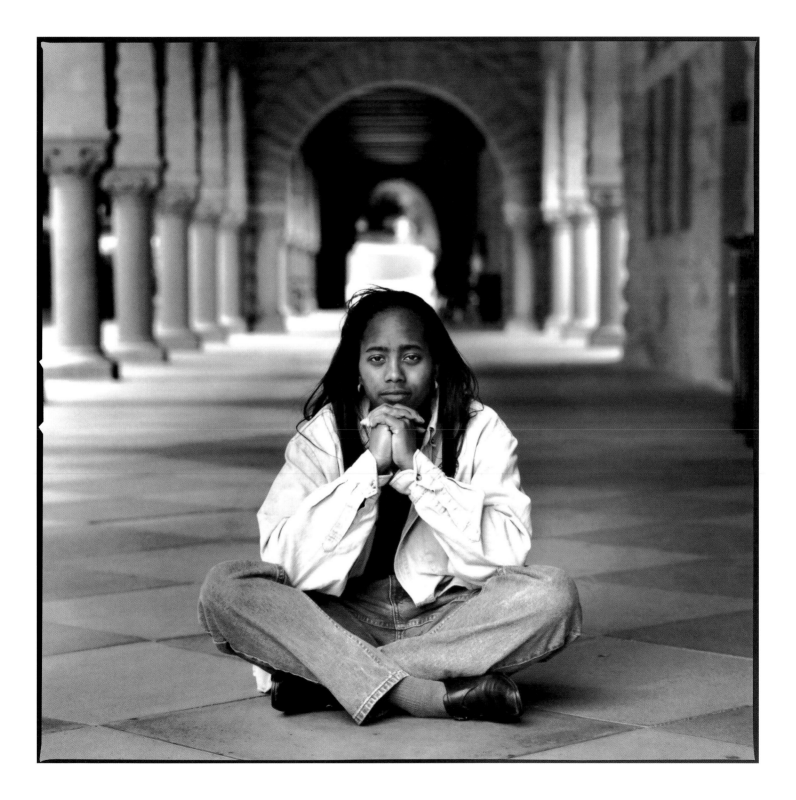

**The questioning went on for two days. There is a church on campus called Black Church at Stanford**, even though it has never been a predominantly black person's church. Everybody goes to the services: Asians, whites, blacks, and everybody. One day I went and said a prayer of rededication to place the Lord as just that: Lord of my life. He was going to be running the ship from here on out. When everything is going left and I need to be going right, I need to hold on to the Lord and to cry out for his grace. Instead of second-guessing myself, all of my freshman doubts were replaced with confidence.

**The ministry I am in has many outreach programs for children and the elderly, but it also has** an outreach to college campuses. There are about thirty-five college campuses in the country involved in the outreach. I could be in Africa or Asia, but I choose to do missionary work on American college campuses because work needs to done here, too. If you look at the lives of a lot of students, you will see that they are crying out for something. I think I have the answer in my Lord. It would be deep if I ran around carrying this big secret, never sharing it with anyone, but I want to give it to everybody. Since I believe in my convictions, it behooves me to share them. If I didn't, you would probably question how deeply I believe. It is a blessing and I never have a dull moment.

**It is also a blessing working with the kids at EPATT. Obviously, it is different working with them** than it is working in the ministry with college students. These kids are more concerned with the Spice Girls. But I also see them challenging each other and having discussions about some of the same issues the college students have. There are no directors or staff members guiding them in these discussions. They just sit around and chop it up about eternity, salvation, the big picture. They do all of this as ninth and tenth graders. It's deep because I didn't have those kinds of questions when I was their age.

**Young people today have to face so much. Unfortunately, I don't feel as if they have a proper** understanding about how to give or receive love. Somebody hasn't given it to them, or they have received it, but they don't know how to give it. As a result, everything they do is driven by this need for love. With a lot of them you can see that lack, and you see them pursuing a lot of things just for a little acceptance. They need role models. When you are "knee-high to a day" and all you need is unconditional love, but you don't get it, that doesn't work. Things get perverted when you need love but don't get it.

In my studies the thing that attracted me to youth development theory is the belief that our young people are our assets, not our deficits. They are resources within the community. They are full of talent, energy, ideas, and passion. Sometimes, when I am driving down the road, I will see a young person hanging out and doing nothing, and I will think, "Man, why are you on the corner?"

People spend too much time trying to be what they think they are supposed to be, in whatever circumstance. I am not concerned what everybody else thinks about me. God loves me, and as long as I remember that I will be all right. I am finally fitting into that perfect box. It's a beautiful thing. Sometimes when people talk to me I can see them getting more relaxed with themselves because they know I don't expect them to perform a certain way. I don't have time for that pretense. Life is too short.

Kesha Weekes

# Yvonne Judice

Born March 7, 1968, Inglewood, CA *The child of a Japanese mother and an African American father, Yvonne has had a difficult time coming to terms with her mixed background. As a teenager, she was stigmatized for being of mixed race and found herself rejecting her ethnicity in order to fit in. After high school, she felt lost and went through a period of drug use. Deciding she needed to change her life, she enrolled at Howard University, in Washington D.C., and the experience transformed her sense of self. In 1991, she graduated with a degree in journalism and went to live in Japan, where she learned to honor her other heritage. After receiving a masters in Integrated Marketing Communications from Northwestern University in 1993, she began working as the manager in the Diversity Department at the McDonald's Corporation headquarters in Oak Bluff, Illinois, developing and implementing diversity employment plans in all areas of the company. She lives in Chicago, Illinois.*

In Crenshaw, where we grew up, people would always talk about my mom. They would call me a "Black Jap." Growing up I never felt accepted by anyone: blacks, whites, or Asians. I felt like the oddball. I always felt that people put a label on me before they even knew me, and it was always negative. When I went to high school, I denied being black. I'm embarrassed to admit it, but at the time I never said I was black because everyone else was white. I got so hung up and wrapped up in what other people were saying about me that I just made it into something bigger than it was.

My senior year I felt like I came out of the closet as far as being black and being Japanese. I finally felt more comfortable being around black people. Before that, I had felt bad because I was living in this lie and I couldn't really talk to black people. When you are that age, around pretty much all white people, and you don't even know who you can be friends with, it's hard. Today, I am so proud of who I am. It used to be my greatest liability, but now it is my greatest asset.

Some people don't even think that I have black in me. One guy who is a supplier to McDonald's drove with me to pick up someone from the airport. At that time David Justice, a black baseball player who played for the Atlanta Braves, was just traded to the Cleveland Indians. The guy and I were chatting, and I said to him, "Atlanta must be a great place to live, but you guys just lost

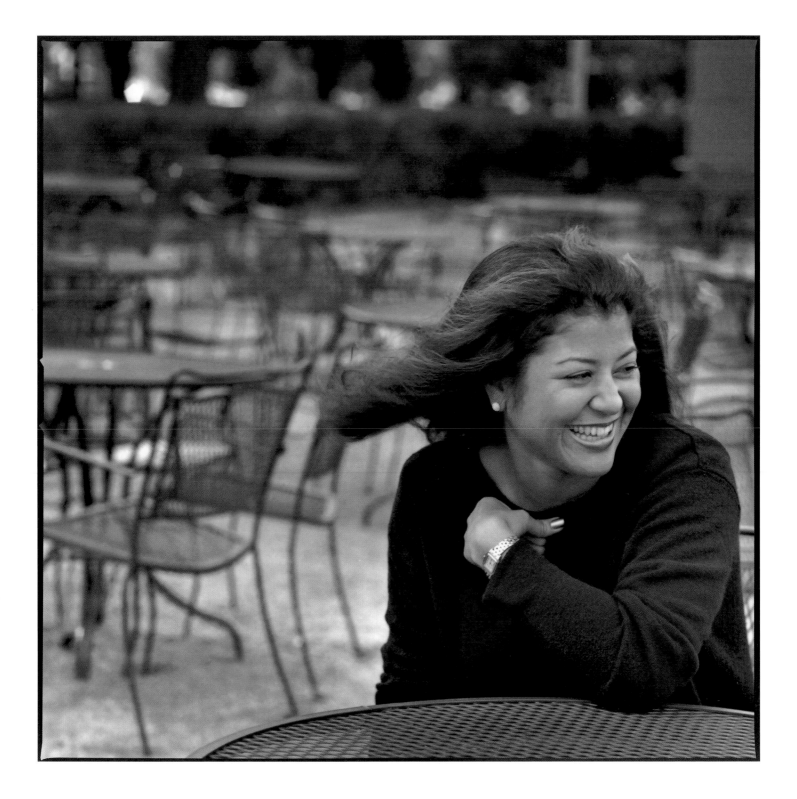

David Justice." He said, "We don't care about him. He does that nigger-shit." He went on to say that Justice was always complaining about things that happen to him because he's black. "Our kind doesn't miss him."

I'm sorry, I may not look black, but I sure as hell don't look white. I'm a minority. When we got to the airport, he came back hugging the guy he picked up like this was his buddy. The man was black. I called him later to tell him that I was black and that he needed to watch what he said to people, and his response was, "I wasn't calling him a nigger. I was just saying that he does nigger-shit." Mind you, he is a supplier to McDonald's, and he leaves this on my voice mail. I still have that voice mail to this day. Sometimes I just have to remind myself that there are people out there who may hug you, and in the next five minutes they will be talking about you.

Before coming to McDonald's, I had smoked pot for years. After high school I went to a junior college for two years and decided that getting high was more important to me than going to school. I quit school and worked three jobs to support my habit, which had become more than just pot. I started bartending but did nothing career-oriented. After work, people would come over to my apartment, and we would sit there and get high until the wee hours of the morning. The next day we would start right back again after work. I was twenty-one years old, I had made so much money working two jobs, and I had nothing to show for it. One day, I was watching the television show *A Different World* and that made me want to go to a black college. I had never been around positive black people—people who were successful or smart—but that was now depicted on the screen.

I applied to Howard University, got in, and it totally changed my life. I went there as a child, busted my butt, and I graduated as a woman. I had left something behind that I didn't need in my life anymore: a lot of toxic people. After I graduated I came back home for a couple of months and decided to live in Japan.

I had been subconsciously angry at my mother for being Japanese and allowing people in the neighborhood to say bad things about her. My time in Japan taught me a lot about who she was as a person and the values that she was raised with. You know how they say, "You have to walk in a person's shoes to understand them?" Well, I think that I got a little bit of a walk. I also learned so much about myself.

Yvonne Judice

# Michelle Genece

Born November 24, 1970, Sudbury, MA *Michelle is a producer for* ABC World News Tonight Weekend. *For each piece she produces she feels it is her responsibility to evaluate not just the needs and requirements of the story but its portrayal of African Americans as well. She wants both to be fair, accurate, and balanced, and she accomplishes this by being as honest to the field of journalism and to herself as she can. She lives in Brooklyn, New York.*

When I was seven my whole world literally consisted of running around and picking blueberries on Blueberry Lane. Don't worry, the birds weren't coming in to dress me like Snow White, but there were no big traumas or neuroses. I was truly blessed to be born into my family. When my father was eighteen, he came to this country from Haiti to study. He brought my mother over four years after he arrived, and now has been here for forty-one years. We lived in an environment of love, discipline, and hard work.

That all translates well into my work. I get a lot out of producing. When I do it right, and I do it the way that I want to, I get a sense of the impact information, or the image, can have on somebody. The idea of putting something on the air that a lot of people are going to watch and say, "Wow, I didn't know that," is a lot of responsibility. The idea is to get somebody to react to something in a time when everyone is so full of their own world and a little deadened to outside forces. To me that idea is very big. I don't know whether or not people will actually do something in response to seeing my stories because that is another step. But, at least, we are making people aware of the information.

It's a big responsibility, and I'm always wrestling with that. I try to be as honest as I possibly can about what I am producing. I really try to get to the essence of what it is, and because I am the one producing the piece, I can't get caught up in everyone else's politics of it. With that said, it is also true that as a black producer, I sometimes feel as if I have to represent the entire race and make everything regarding African Americans look fabulous. It's as if I am policing. The question then becomes, "Am I a journalist or am I an activist?"

The answer is that I calibrate the situation. I am on that fence all the time. Because I am a journalist first, I err on the side of journalism. I can be fair in the representation of the piece and not only look at welfare mothers who are black. I have the control of deciding who will represent this

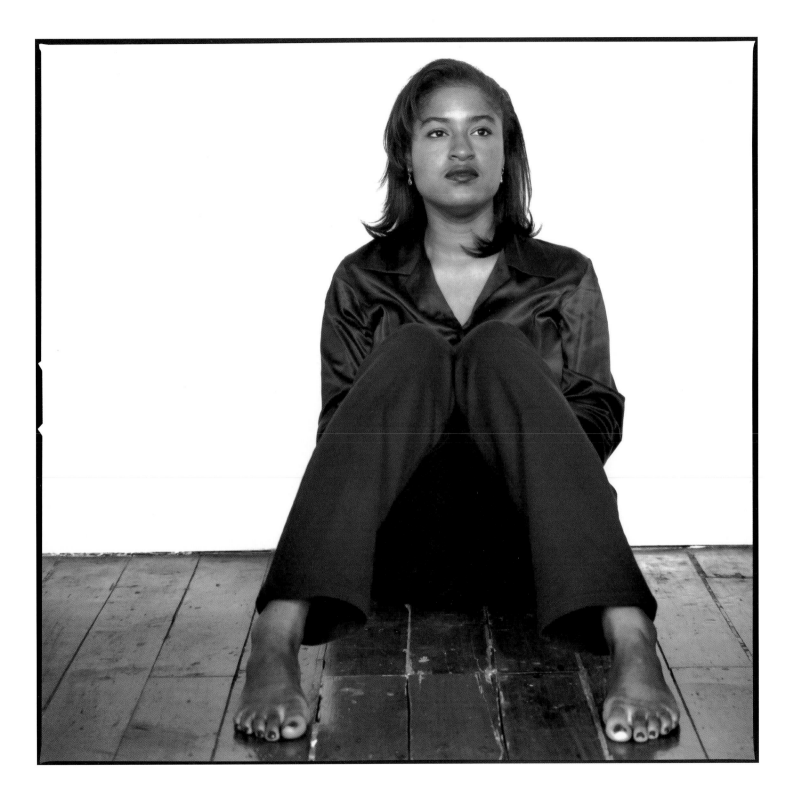

story. That is when I think I am fueled and informed by my perspective because I know what the situation isn't. Personally, I have a responsibility to be honest and courageous to myself and to influence and inspire others.

Many of the black people in these large media organizations, including myself, have gotten in because we are not threatening. We went to the "right" schools, have the "right" items on our résumés, and use the "right" language. That disturbs me because while these organizations talk about diversity in terms of bringing in different-color faces, there isn't the diversity in bringing in different life experiences. I don't want to sound so general as to say that we all come from the same experiences, but I think we are safe for the traditional structure. You shouldn't have to go to Harvard, Yale, or Stanford to work at ABC. I don't see much diversity in that.

To some extent I think that it is true that affirmative action has only benefited the middle class because it's getting to the people who have the resources and are ready to run in the door when it opens. But what about the people who don't know where the door is and were never told that there is a door? What about the people who haven't yet developed the sense that they are special, that there is something inside of them that will allow them to be successful? Because of their circumstances, they haven't gotten there yet. How do we get there and develop that?

It reminds me of when I covered Pat Buchanan for his presidential campaign in 1996. It was really an interesting experience. Toward the end of the campaign, Pat, his wife, Shelly, their press secretary, Greg, and I were joined by a whole press corps. We boarded a flight on one of those cheaper airlines where the flight attendants were all wearing the same thing, like shorts or something. At one point I got up to visit the campaign person, and as I walked down the aisle this woman, whom I didn't know, reached over, touched me, and asked me to throw something away for her. I said to myself, "Do I look like a flight attendant?" I had a huge ABC News Buchanan Press Corps pass on my chest, and I just looked at her, and I said, "I'm not a flight attendant, ma'am." You should have seen her face. The juxtaposition of being at the height of your news organization—they're trusting you to be ground zero for a campaign for the Republican nomination of the presidency of the United States—but despite that level of professional responsibility someone can expect you to service them? That was amazing to me.

For me, you are what you are: a genderless and raceless spirit. Being African American is a role, being a woman is a role, and being a daughter is a role. It is almost like tuning an instrument, and you keep turning the different knobs one way or the other to get the right sound. You keep going through, tweaking knobs, until you get what you want. The problem is you get wrapped up in all the roles—an African American woman, a woman, a daughter—and you don't get to the essence that fuels them. What I come up with when I tune my instrument is a combination of the fairness and wisdom of Barbara Jordan, the power to influence and inspire of Oprah Winfrey, the creative mind of Toni Morrison, the courage of Tina Turner, and the capacity to love and the soft touch of my mother. Well, you can add the legs of Tina Turner as well.

Michelle Genece

# Theresa Jones

Born May 31, 1966, Hollywood, CA  *Theresa has been through more fluctuations in emotion in a year and a half than most of us will go through in a lifetime. Not long before she became pregnant with her daughter, she noticed a pea-sized lump in her left breast. But a series of doctors ignored and misdiagnosed the tumor throughout her pregnancy and after childbirth, telling her it was nothing to worry about. Eighteen months later, when the lump was finally removed, it was discovered to be cancerous, and Theresa decided to have a radical mastectomy to remove any other possibly cancerous tissue in her breast—all of this before her thirty-first birthday. She lives with her husband, Martin, and their two children, Hailey and Dylan, in Richmond, Virginia.*

My mother gave me my sense of style and the ability to be tolerant of all people. She gave me my ability to be patient and loving. My father gave me my assertiveness. The Bible has been my road map. It has steered me on the path of wife and mother and put my other dreams of acting on the back burner.

When I was twenty-eight, I found a lump in my left breast. I went to a very high profile gynecologist in Beverly Hills. I was trying to figure out some way to curtail the effects of my premenstrual syndrome and at the same time I told him, "By the way I have this pea-sized thing in my left breast." He said it was probably nothing and gave me some vitamins for the PMS. The second time I went to him was to tell him that my period was late. Of course, I was pregnant with my first daughter, Hailey. When he found out that I was pregnant, the pea-sized lump in my breast was chalked up to "pregnancy related," and "Let's not worry about it right now." I didn't see him again because we had to find another doctor after we switched insurance companies.

I went to another very high profile doctor, a woman who works at Cedar Sinai, and started prenatal care with her. Immediately, I told her I had a lump in my left breast and that I was four weeks pregnant. Through prenatal care, I saw her every month to get checked out. The lump was getting bigger. She continued to say that it was nothing. She said it was pregnancy related and I was "only twenty-eight." "Let's just keep an eye on it, but don't worry, it's probably nothing." Finally, I think I was four or five months pregnant, and I wanted them to make sure it was nothing. Reluctantly, she sent me over to get an ultrasound on the breast. I could tell by the way the technicians were examining me that something was wrong.

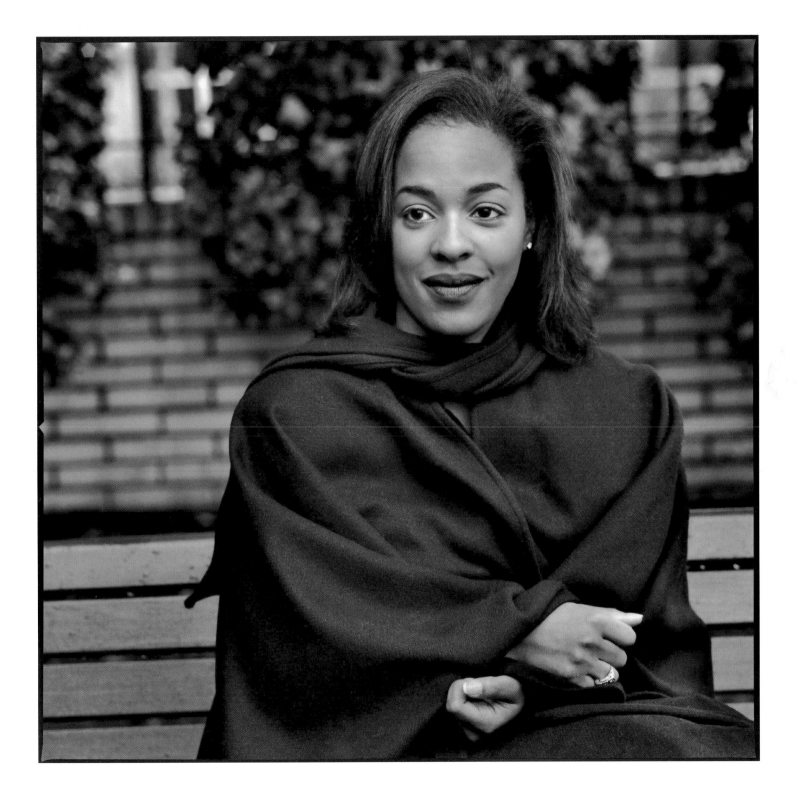

I was anxious to get back to my doctor and find out what they had found. Weeks passed and I saw her two or three times, but each time she told me she hadn't seen the findings but when she got them back she would let me know. Again, she told me not to worry because it was nothing. She probably didn't even look at the findings. Because of the pregnancy my breasts were getting bigger and made it seem as though the lump was getting smaller. One morning, I went to the emergency room because I had so much pain in my breast it felt like it was burning. My doctor said that it was just part of the pregnancy. They told me to take Tylenol, and I did. I was near nine months and became convinced it was nothing. I decided I wasn't going to think about it because the baby was coming. I had a normal delivery and everybody was healthy and happy.

Simply because her bedside manner was horrible and she was too rushed, I never went back to my Ob/Gyn for the six-week checkup. At this point I was breast-feeding and because the milk was being released, you could definitely tell that there was a lump. It had tripled in size. I chose another Ob/Gyn, who told me it was probably fibroadnoma. He was the third doctor guessing. Now it couldn't be pregnancy-related because the baby was out. It had to be a clogged milk duct. "Let's breast-feed the baby and put hot compresses on the breast and see if it drains," he told me. It never drained. The lump was getting bigger. Every time I went back to him I would tell him the lump was still there. My baby was now almost six months old.

At least he had the sense to say that he didn't know what it was. So he sent me for a mammo-gram and ultrasound. The mammogram doctor looked at my film and said, "I don't care what this is. It is over four centimeters, and it has to come out. I don't care: clogged milk duct, fibroadno-ma, whatever." She sent me over to a surgeon, Dr. Jonathan Heard, whom I love like a father. He touched my body and said, "I've got to get you into surgery tomorrow." He was shocked, appalled, and disgusted that any of his colleagues could allow a patient to have a mass this solid, and one that you could feel so plainly, in her body for so long. They took it out. Two days later I returned to get my wounds checked. I was chipper and asked him if the pathology reports had good news. He told me they didn't. It was like someone had kicked me in the stomach.

I was there with Hailey, nine months old and in her stroller, and they were telling me I had cancer. It was one of the rarest forms of cancer. There were so few cases they didn't really know what to tell me to do. Do I get a mastectomy, or do I let them take more tissue to see if there was cancer around the lump? Do I radiate the breast? What do I do? On the trip home I cried so hard I

couldn't even see. To show you what a blessing kids are, Hailey knew something was wrong. I put her down and told her, "Mommy is sick." With her little baby hand she touched my knee and sort of patted me. Our whole lives were turned upside down. Marty, my husband, had just started a new job, and his wife is sick and he has a new baby. It wasn't like he was going to take off work, because that was our health insurance.

That entire month I read and researched, and called my mother, father, and the church. Two of three doctors said I should get a mastectomy. One month later, I decided to have a radical modified mastectomy on my left breast. That means that they basically leave me with a flat sewed-up chest. It wasn't clear how far out to the edges the cancer was. The farther out means that some of the cells may have escaped from the tumor into the tissue around it. Because that was not clear, I said, "It's a breast. I can get a new one." I didn't want to take any chances.

By the time I got to surgery, I wholeheartedly knew I was going to live. I had begun to pray and really talk to God. I brought over a bunch of my friends and people from church to pray for, and with, me. Whenever I would feel doubtful, I remembered Psalm 118:17, which says, "I will not die but live and proclaim what the Lord has done." I shall not die but live. Eventually you become what you say.

In the beginning the surgery affected the way I saw myself as a woman. To keep a patient from being completely debilitated, the hospital puts on pads and tons of tape, to give you the illusion that there is still a breast. At each checkup they take off more until you are left with surgical tape over the sutures. I remember being in the bathroom with Marty, and I just broke down. I cried and he held me. I don't even remember him saying anything. But the way he held me, it was clear he didn't care if I was missing a head. I was still his lovely wife, and at that moment I felt whole. That was the beginning in healing my perception of myself as a woman.

Later, when Dr. Heard came to me with the pathology report, we gave each other a high five when I saw the report, "Eight auxiliary lymph nodes: tumor free." It has been one year and eight months, and all of my tests are negative. I'm cancer-free and pregnant with my second baby.

T h e r e s a   J o n e s

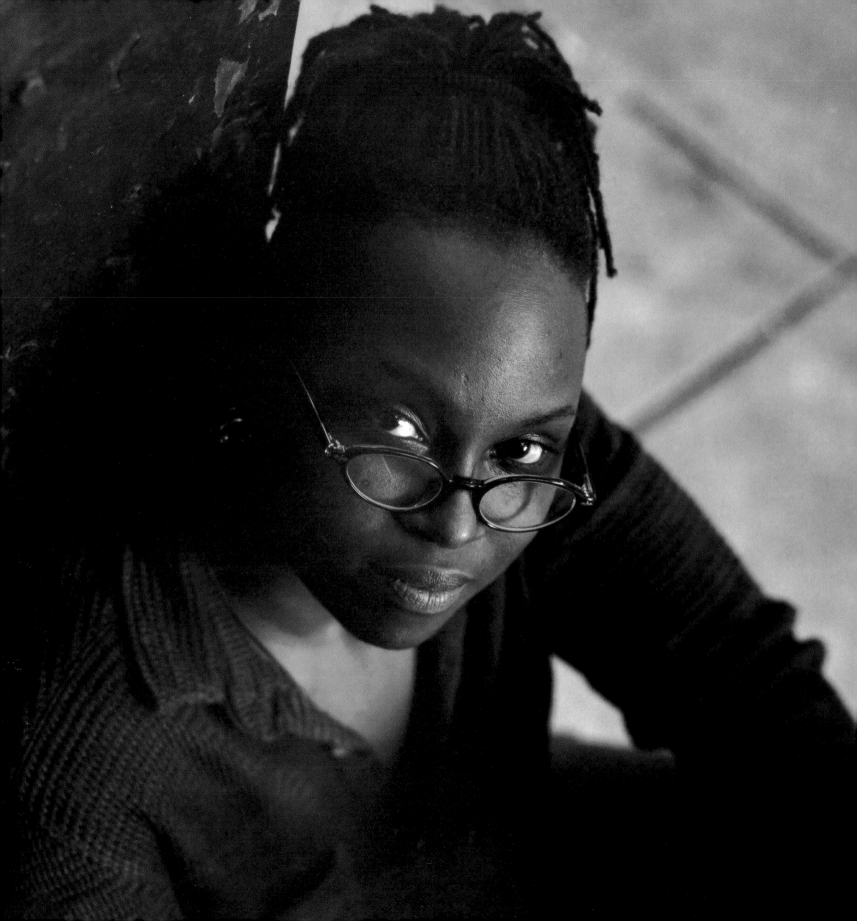

# April LeBlanc

Born January 28, 1963, Los Angeles, CA          *April is an exceptional, highly respected veterinarian who is dedicated to providing affordable veterinary services for low-income people, especially for those, such as the elderly, who benefit most from the companionship and love of pets. Along the way, as a lesbian, African American doctor who enjoys having dreadlocks and a shaved head, she hopes to confound a few stereotypes as well. She rarely looks the way people expect a doctor should, and she doesn't mind, since ultimately her abilities as a vet speak louder than any stereotype, as her peers at Pets Unlimited Veterinary Hospital and her many dedicated clients will attest. She lives with her two dogs, Hannah and Oscar, in San Francisco, California.*

**My mom is probably the most important person in my life and I credit her with who I am today.** When I was seven, I told her I wanted to be a vegetarian because I loved animals. She said, "No dear, that's a veterinarian." My goal as a vet has always been low-cost veterinary medicine because it allows many people to have pet benefits, such as the alleviation of depression and alienation. There are elderly people in low-income areas who lock themselves up behind the bars of their homes. They don't come out during the day or during the night. In addition, they may not have any family who visit them. It would be wonderful if they had a little dog or cat they could talk to and who gave them that companionship. At the same time, it would be great if they didn't have to worry about affording it.

**I have only worked for nonprofits. I worked for the San Francisco SPCA for three years. The** entire time I was there I never had to perform euthanasia on an animal due to a client's lack of funds. Animals of homeless people were treated in the same way as rich people's animals. Once a homeless drag queen came in because his dog had jumped out of a window. It had woken up that morning in a new place, didn't see him, and panicked. With mascara running down his face and his pantyhose torn, the guy put the dog in his shopping cart and pushed him from vet hospital to vet hospital. It was a sight. I just love that I could give him a hug and tell him not to worry because we would do all that we could for his dog. Also, it was great to tell him that he could pay off the bill in old blankets and towels if it was necessary. It turns out the dog just had spinal shock and fully recovered.

**I know I am a good vet.** The technicians here at work ask me to take care of their pets. That means something. I take care of animals *and* I connect with their owners. I also make other clients think about their stereotypes. I like the fact that when I walk into a room, clients see a black face with dreadlocks and a shaved head. Maybe they can tell I am a lesbian, or maybe they can't. I used to think I had a big *L* on my forehead, but some people don't figure it out. I love the little white ladies from Pacific Heights, a rich neighborhood here in the city, because I love to have them come in feeling one way and leave liking me. When that happens, I feel that I have broken down some stereotypes. They might look at other black people and think twice about what they automatically assume.

**I recently went into an observation room occupied by an attorney, her husband, and their Chow-**Chow mix dog who had been throwing up for the past couple of months. The dog was nice and I was greeting her down on my knees and right in her face. The dog was completely nice to me. Out of the blue, the woman says, "I don't know how she is with black people. She hasn't been around a lot of black people." I said, "Well, if she reads the paper or watches television, I'm sure she'll bite me." It's true that you sometimes will see dogs that are funny with blacks, or whites, or Asians, or whatever. But this dog was obviously okay with me. So there was no need for the conversation. It was ridiculous.

**She was probably taken aback by my appearance, and something had to come out of her mouth.** I responded that way because I wanted her to see how foolish she was. I get people like her who are nervous with themselves, and I also get people who become bent on a second opinion. It doesn't bother me because I believe any doctor who is confident in what they are doing is not going to be offended by a second opinion. Second, it is only going to prove that I am right. My philosophy is, "Go and spend more money at another place to have them tell you exactly what I told you. Then, maybe, it will force you to look at why you had so much doubt."

**It's funny because I get the good and the bad. The good comes as one white woman in her fifties** who came in to support her friend who had brought in a pet. It was a euthanasia case. She came to support the friend and I talked them through it. Afterward, as I was giving the owner a hug, the woman came up to me and said, "You go on, sister. It's nice to see you here." She didn't mean sister as a black thing but more as a feminist thing. I love that.

I like my appearance. I can finally look in the mirror and say, "Yes. That's who I am." I feel as if I fit into who I am on the outside. Even though my appearance is not meant to shock people, I admit I like that effect because I sometimes like to jolt people who have a comfortable way of thinking. For those people, dreadlocks, multiple pierced ears, and a shaved head might mean "unintelligent," or whatever. When I was at Mount Holyoke finishing up college after a year at Tuskegee, I told my classmates, "I'm here, but I am not any different from someone on the streets in Watts, California. I'm lucky. There are people over there who are just as intelligent as we are here."

I went on to tell them that they were born lucky. So much of what you become is based on what family you are born into. Some people are born into a wealthy family in Connecticut, and some people are born into a family with a dope-addicted mother in the projects. It's the luck of the draw. People need to understand that and not get superior and up on a high horse. To this day, I get clients who have no money and possess a limited education. I speak to them in a way that will make them feel comfortable. I don't make assumptions. I just recognize how lucky I really am.

April LeBlanc

# Dionne Scott

Born May 9, 1969, Monroe, LA          *As a child growing up on an overseas army base, Dionne didn't perceive any difference between herself and her white friends. Then her family moved back to the United States, and she found herself having to wrestle with numerous questions of what it means to be black, and she internalized the societal perception that she wasn't as good as her white peers. These feelings persisted even after she graduated from Stanford University in 1991 with a degree in history and feminist studies. Today, she is learning to value and trust her talents. Dionne works as a news assistant for the WB network. In 1997 she received two Excellence in Journalism awards from the National Society of Black Journalists for a segment she directed and produced for cable station New York 1. She lives in Brooklyn, New York.*

My father was in the army, and during his tour in Germany, I was like most of the kids that I was around, and they were white. I had white friends and I never really thought about color. Then I moved to Fort Hood in Killeen, Texas. The kids would say that I seemed so proper. When I went to Louisiana to visit my grandmother, it was the same thing. I started to notice how many people would say that I sounded white. I remember asking myself what it meant to sound white. At the beginning of junior high I started to recognize my blackness. Not that I ever denied it before, but it became more of an important thing for me. I recognized things you would consider were a part of the black culture differently than other people. It was not that I had never had black friends before, but I started to hang out more with just the black kids. I found myself trying to change the way I talked, too.

There was a time when I wished that I had white features: the straighter hair or the thinner nose. It was the beginning of my freshman year in college, and I hadn't really been politicized. I even went through a phase where I wanted to get colored contacts. We were having discussions about straightening hair and wanting lighter eyes, and I remember talking to my brother about it. I asked him if he thought that it meant I was trying to look white. He said, "Maybe if you really think about why you want lighter eyes—that it would make you more attractive—you would see that it might have something to it." He was right. When I sat down and thought about it, I saw that I had been taught that good hair and light eyes made somebody pretty.

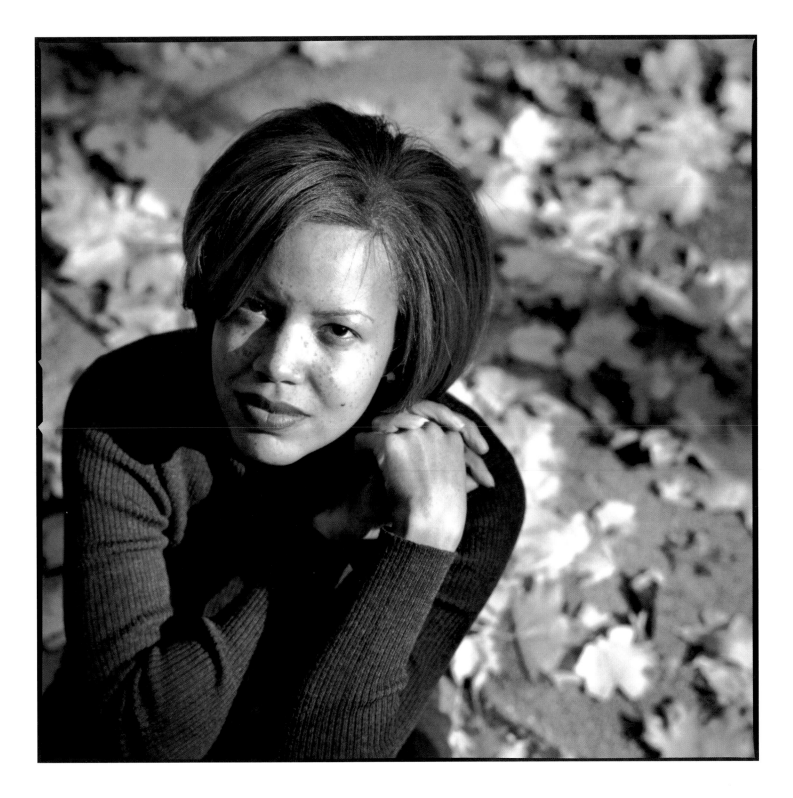

**I am African American before I am a woman. Partially that is what has been imposed on me and** what people notice when they first see me. If I was to think about what has been a source of insecurity for me, being a woman is not one of them. I don't think I have ever had questions about whether my being a woman would prevent me from doing something. As a woman there are things that I struggle with, but I don't feel overburdened. There are other people who are more so than I am.

**I noticed that struggle when I went to Stanford University. In high school, without a whole lot of** effort, I was always the smartest kid in the class. I did my homework in front of the television and talked on the phone. Then in college I found myself around a whole bunch of kids who were the smartest in their classes and who had gone to better schools than I had. One of my teachers in high school said to me, "Because you are black and a woman, it will help you to get into the Stanfords and Yales." What he said struck me, and I didn't like it. I wasn't sure how to respond; I just knew that it bothered me. Another time on the track team one of my teammates said, "Well, the only reason you got into Stanford and Yale is because you are black." I was mad when he said that, but I still had that thought in the back of my head. I knew that school had been easy for me, and I had never really worked that hard. Maybe I wasn't really supposed to get into those schools. Then being surrounded by all of those kids who were just as smart, or who had been exposed to more things, made me feel *less than*.

**Two people saying something to me shouldn't have changed my way of thinking that completely,** but it is like what my mother said to me one time, "You can't escape what society has been telling you all this time. Somehow it seeps in." Maybe not wholeheartedly, but somehow it had touched me. I was scared to try harder because I would then set myself up to fail. I didn't even talk in class. But the one thing that I could fall back on was my writing.

**After graduating, I tried to support myself living in New York. I backed myself into a corner. It** was to the point where I had to think twice about buying a candy bar because I needed to save money. I wanted to pursue writing in magazines, and I applied to a Radcliffe College publishing course and got in. I was amazed because my grades were horrible, and at the time I still had little self-esteem. When I got in it was a real sense of accomplishment. It was something I didn't think

I could do. Then when I went to the course—an eight-week program at Harvard—and was not overwhelmed, I felt much better about myself.

Afterward, I got a job at Time-Life Books, and I thought, "Oh, I'm not so bad after all." I think that job was a continuation of my growing confidence. I was a researcher on a three-volume series on African American history and an assistant editor. I had to present the information in front of a panel of people, and that was good for me because I found out that I was capable of speaking for myself.

I think I am still developing. There are certain insecurities that I need to let go of. There are things that I need to accept about myself and embrace and place myself at equilibrium with. I want to be at peace with those things. When I am in that place, where I am accepting all of myself, then I think I will be the person who I am supposed to be.

Dionne Scott

# Duchess Harris

Born May 16, 1969, Newport News, VA *Duchess's grandmother—whom she was named after—worked for NASA as a human computer (a precursor of today's computers, responsible for the countless calculations required for each mission), and her mother grew up on the campus of the historically black Hampton College. Today, Duchess is a professor of African American history at McAllister College, and she relishes the stage of the classroom almost as much as sharing her rich African American heritage with her students. She lives with her husband, John, in Minneapolis, Minnesota. They are expecting their first child in January of 1999.*

The first time I realized I was black I was in the first grade. The town I grew up in, Reading, Massachusetts, had a lot of Irish families living there. One day, close to St. Patrick's Day, the kids in the class were talking about being Irish. They were proud of it. The teacher was pointing out that one student was Italian, another was Irish, and so on. When I got home I asked my parents, "If she is Italian and she is Irish, then what am I?" My parents would say, "Well, we're black." My next questions were: "Do we get a country? Do we get a flag? Signs? Anything?" I was kind of bumming. It seemed like I got the short end of the stick.

At the time, my parents were big on watching the local news during dinner, and one day police officers were beating on blacks somewhere in Boston. Before dinner I had watched *Sesame Street*, and one of the pieces was about "people in your neighborhood." I learned that Mr. Policeman was supposed to be good. Then I saw Mr. Policeman beating up black people on the news. Of course, I started thinking, "Maybe this black thing isn't so cool." That's how I was introduced to blackness.

Going to the University of Pennsylvania changed my life and put a stamp on what blackness truly was. I was a double major, with one part being Afro-American Studies. Because I had grown up with so many white people, it was the first contact I had with so many brilliant black people. I studied with Mary Francis Berry and Evelyn Brooks Higgenbotham. Studying in that kind of environment provided me with so many things, including various ideas on my career choices. But the best thing to happen to me has been this move to Minnesota. I was kicking and screaming when I had to make the decision to come because I thought it was going to be horrible. But nothing but good has come of it.

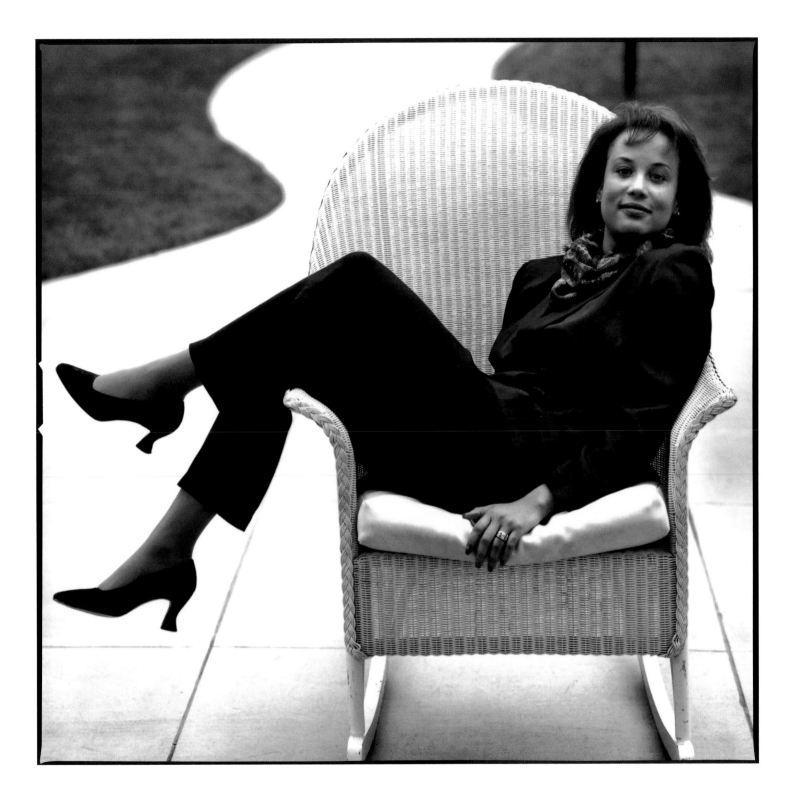

One of those good things—even though I didn't think I would like it and was doing it in graduate school only because I needed to pay my bills—was teaching. But I found that I loved it. To be honest, part of the reason why I love it is because I get to be on stage—there are a group of people who *have* to listen to me. And, for somebody like me, that is pretty appealing. It's kind of like having your own personal *Oprah* show every day. That's the silly sense of it. The real sense of why I love it is that I can enlighten people about black history. That is what I teach. One course is called Race, Ethnicity, and Politics; another one is Black Public Intellectuals. I get the opportunity to expose students to information that they never would have had access to. That feels great and makes you feel that you can have some impact. Last semester I taught Modern African Political Movements, and by the end of the class a lot of the white students from the Dakotas wanted to be Black Panthers. It was hysterical.

I truly became a self-actualized person after moving here in 1991. I became a homeowner when I was twenty-four, even though it was an intense road from beginning to end. I was at the end of my second year of graduate school in 1992, and I knew my fellowship income was going to come as a teaching assistant, which meant that I would be getting less money than I was at the moment. I was only going to be making about $800 a month, but rents were between $400 and $450. I didn't know what I was going to do. At the time, I had been volunteering for a democratic senator, Paul Wellstone, as an intern working in housing and urban development. Many people came into the office saying they were low income but looking for a way to buy a house anyway. The funny thing is that I realized they were all making more money than I did. I also realized that until the Ph.D. panned out I wasn't going to be making money for quite some time.

I found a house in north Minneapolis, the most black-populated section of the city. An elderly couple who were going into a retirement home had lived there for forty-five years. From my time working in housing and urban development, I understood that I could get an FHA loan for $30,000. I initially put $500 down, and $1,100 by the closing. My mortgage would be $268.37. As I said, I was twenty-four years old. My mom's voice was ringing in the back of my head. "Go for it," she was saying. So I went for it.

Buying the house was a metaphor for carving out a place for myself in this world. Although it was so empowering, I also experienced so much discrimination going through it. It was fascinating.

One time I was getting homeowner's insurance, and the agent asked if I had a husband. I told him I didn't, and he wanted to know why. He asked in a way that indicated to me that something was wrong with me wanting to buy a house without a husband. He was an older guy who didn't, and couldn't, understand.

Before being offered the house, I had been riding the bus for three Minnesota winters while attending graduate school, and I asked a friend of mine to move in with me, partially because I didn't have a car and he did. He is a black gay male, and the Realtor was particularly homophobic. He treated us with contempt. From working with Senator Wellstone, I knew I qualified for the loan on the house. But I also learned that when you make only $10,000 a year people will treat you like dirt. If I didn't have as much educational privilege as I did, my self-esteem would have been at rock bottom, and I probably would not have had the perseverance to go through the process.

Good things have continued to overwhelm the bad, though. In August of that year I moved into the house, but then on October 10 I went out on a date with this guy who ended up being the love of my life. Thirteen months later, on November 26, 1994, we were married—and are happily married to this day.

Duchess Harris

# Piper Dellums

Born November 23, 1965, Berkeley, CA *If there were ever a person who spoke to the strength of the human spirit, Piper would be her. The daughter of fourteen-term congressman Ron Dellums, Piper once dreamed of following in her father's footsteps, but she was raped in her junior year of college and for a decade suffered through depression and an eating disorder as a result. Despite this, she has hosted a television show on Nickelodeon and appeared in numerous television commercials. She has worked toward a doctorate at New York University, helped to found Baby Earth, a school for ecological awareness, and written for* National Geographic. *Then, in October 1997, she faced more adversity when she discovered she had breast cancer. Her breast cancer was cured, but after undergoing chemotherapy treatments, she is now being treated with radiation therapy to battle the cancer that has metastasized to her stomach, colon, and brain. She lives with her two daughters in Kensington, California.*

When I was five, we moved from Berkeley, California, to Washington, D.C., because my father, Ron Dellums, was elected to Congress. We were on a trolley car and the Delfonics were singing "Didn't I Blow Your Mind This Time." People were patting him on the back as I held on to the leg of his pants. It was overwhelming, and I had so much pride. But his job also gave me a strong sense of loss and yearning that comes from not having a father around. I felt like I was raised in a single-parent household. An unspoken cloud of absolute sadness hovered over our home and affected pretty much all of us.

When I decided to go to college, I wanted to follow my dad's footsteps and went to the University of California at Berkeley. I was jumping into this dream of my father's world and the world that I was uprooted from. But I was raped in my junior year, and my life was taken away for something like ten years. At the time it happened, I was always taking in people who were homeless. I saw a woman—a kid, actually; she was seventeen—sleeping in a car, and I moved her into my apartment and she slept in the same bed with me. She was a crack addict. I made it clear that she was not going to smoke in my apartment. The man who raped me was someone who liked her. He lived in the laundry room in the basement of my apartment complex, and every morning and evening I went down and brought him food. He was just a homeless guy. Old, I thought. I

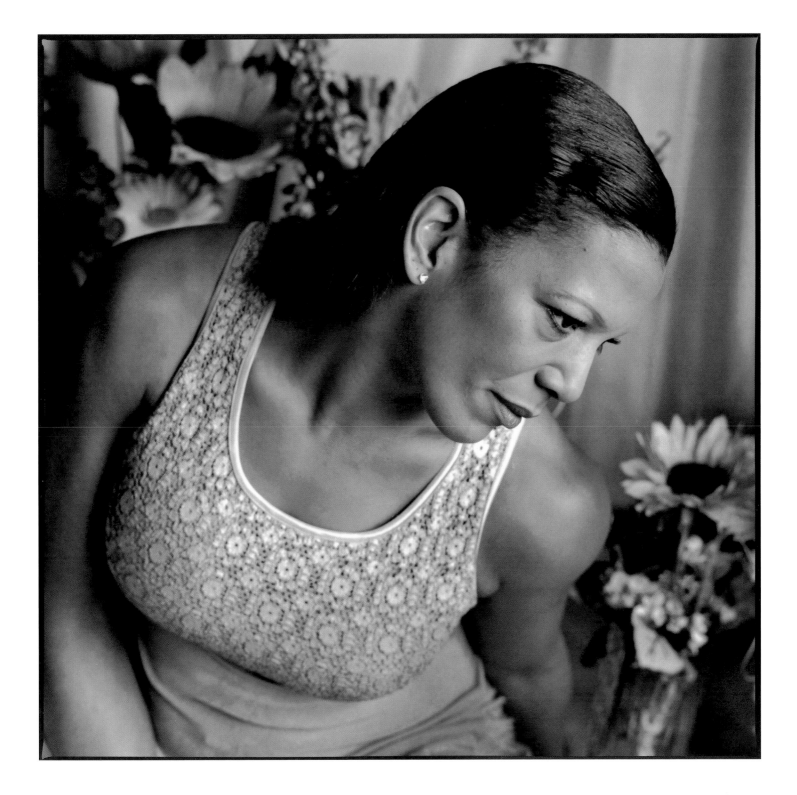

would chat with him and bring blankets when it was cold. I was sodomized, brutally beaten, and went through hell. I couldn't understand how I could feed a man for six months and then he could strip me of my innocence and deprive me of my life in an eight-hour period.

It completely changed my life and sent me into a series of emotional problems, including depression and an eating disorder. I moved back to D.C. still going through post-traumatic stress disorder. I was going through a lot of self-hatred and didn't believe anyone could love me. I met a guy who at the time I thought was nice and safe, and we got married. I was ninety-eight pounds when I met him. I think I respected him, but I don't know if I was ever in love with him. That someone had asked me to marry him was so unbelievable to me. I just remember thinking that I had to say yes, but somewhere inside of me something was going, "What did you just say?" We were married for eight years.

I was afraid of so many things at that point. We run through life being indoctrinated by everyone's fear, listening to it and allowing ourselves to be crippled by racist and sexist environments. We are judged for not being black enough, or smart enough, or gay. All these things make us angry. My ex-husband's father hired him to work in South Africa. When we moved there, I discovered that it is a place where being black is considered to be profane and inhuman. It makes the United States look like heaven. Here, we *are* allowed to go into shopping centers, own homes, live with our families, and have electricity. We *are* allowed to be on the streets after dark. I was so angry about the way the blacks were treated, but then a South African friend of mine said to me, "Don't let out the devil inside of you." That changed so many things for me. I realized that black South Africans didn't harbor the anger we harbor here. They know exactly who they are, and assimilating is not at all what they are about. Just being black is a beautiful thing. When I started looking around and talking to them, it was like I was seeing a million Mandelas.

So now I think the reason God threw all of this on my plate is because I have two children to live for. I have to teach them how to rollerblade, to flirt, to play tennis, to be brilliant, to be interested in biology, to plant gardens, to nurture animals, to nurture each other, to pray, to cuddle, and to laugh.

Sometimes I don't have the strength. In those moments, I'm like, "Okay, I can't handle any more! Can't you see? I'm dying!" I'll just want to curl up in bed for three or four days thinking to myself,

"I'm going to stay like this." I walk around with a conscious awareness of the possibility of death. My dad retired from Congress and practically moved in to take care of me. It must be a strange feeling to bury your child. I know it's been hard for him to give up the life he created for his children, and now change his plans to burying one of them. But I am living. This is living. Whenever I get lost in shutting out the world, one of my kids will laugh or smile. The miracle of their being makes me say, "Oh God, get out of bed!" Then we'll have a blast together. We'll put on tons of makeup, dance around the house, and be the Spice Girls. We all fight over being Scary Spice because she's fine.

Piper Dellums

# Stephanie Robinson-Sullivan

**Born August 27, 1969, Detroit, MI**
*Stephanie considers herself lucky because she had the good fortune of having strong role models—women who supported each other and gave back to the community. As a result of their guidance, her focus is to help those who may not be as fortunate as her. A Harvard-educated attorney, Stephanie decided to trade in the courtroom for Capitol Hill, and she now works for the U.S. Senate Committee on Labor and Human Resources as the chief counsel for Low-Income Policy and Children Affairs. She also serves on Senator Edward Kennedy's staff on the Labor Committee. She lives with her husband, Ronald, in Washington, D.C.*

I believe you are only a sum total of your experiences. My mother and grandmother are very strong and independent women. For a great deal of my life my mother was the only parent. She did everything and did it well. She put my well-being in front of everything she might have wanted to have done and that enabled me to see someone who epitomized a strong, black woman. She made it clear that I should expect to do well, receive awards and the like. She taught me to do my very best and showed me that if I did, I would be rewarded. Luckily, I grew up in a place where it was easy to be loved and to have self-confidence because I knew I had a cushion to fall back on. I also had an extended family that was always very supportive. They were the support mechanism my mother needed. They constantly told me that there was nothing I couldn't do. My grandmother would always say, "As long as you have education, that's all you need. Nobody can ever take that away from you." That, of course, is easier said than done.

I have definitely been shaped by my experiences, but I hesitate to say that my womanhood defines who I am. I first think of what it means to be a good person in this world and what it means to be a human being. I also think of what it means to be an African American in this world. Then, I think of what it means to be an African American woman in this world. Of course, I think *who we are* is shaped or influenced, in some way, by what people expect of us. And those expectations are why we are socialized the way we are. I have not by any stretch of the imagination removed myself from being a woman or being an African American. Those truths are always with

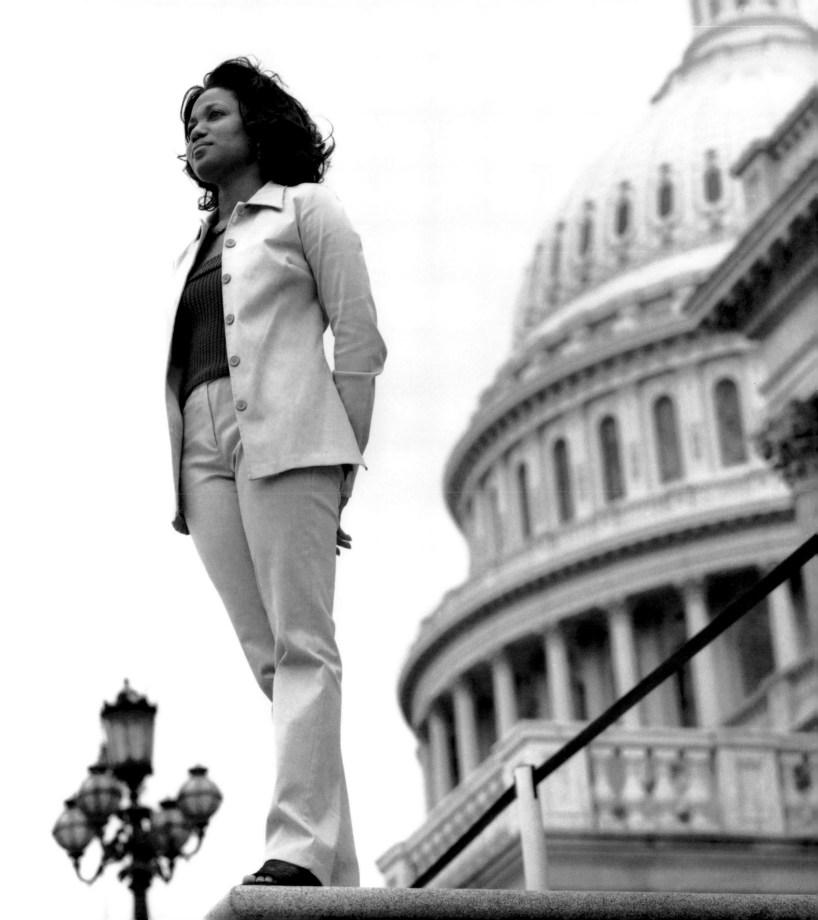

me and they are what people see. The richness of my culture and my people are both very important and dear to me.

I like being a woman, and I wouldn't want to be a man, but being a young, black woman oftentimes catches people off guard. On several different occasions I have been in the courtroom and people have asked me if I was a social worker or a clerk. Rarely was the question "Are you an attorney?" Even in a place like the District of Columbia, where you will find a majority of African American people and African American attorneys, the assumption is that I am a social worker—anything but an attorney.

I was even getting it from my clients while I was working at a firm. When we became friendly with one another, they would refer to me as "Little Stephanie." They would say, "You're young enough to be my daughter." But once they saw me do what I do, I received nothing but respect for being effective at my job. I get beyond the assumptions because I am comfortable with myself, and I work hard to make sure I am sharp and doing good work. I go into every situation believing that I will have to be ten times better than the next person. But I also realize that years don't necessarily equal experience. Often, people will use the amount of years you have been on earth, or the amount of years you have been in a particular occupation, as a proxy to your ability. Yes, you get experience the longer you are doing something, but it doesn't mean that those experiences equal competence or effectiveness. You have to be mindful of that and be open to realizing that you are not going to do everything right. You can ask questions of the people who have had this experience before you. If you are smart, nice, and pleasant, people will want to help you. People want to be able to say, "This is how I did it," and "You might want to think about it this way." You watch and you listen. You can't come in being cocky, thinking you know everything. You just come in being confident, knowing you can learn.

Learning would be difficult if I had to divorce myself, and my values, from my work. It's easy when I can sit there and work with someone like the senator, who believes in what I believe. I can't speak enough about waking up in the morning and wanting to go to work. I like what I do and I like who I am. I really like Stephanie. It's not that I don't get frustrated by parts of myself or by my reactions to certain things. It's not that I'm not hard on myself, because I am. But at a

very young age—and it's cutesy to say—I took to heart the belief that if you can look in the mirror and be proud of the person you see, then you're okay. I like what I have become, and I hope I will continue to become a better person. Until then I like the fact that I am committed to my ideals and that other people, money, and other external things don't dictate who I have to be.

Stephanie Robinson-Sullivan

# Marshelle Jones

July 17, 1970, Baltimore, MD                    *Marshelle is a Ph.D. candidate in anthropology at the University of Berkeley, but instead of studying distant cultures of ancient times, she has turned the anthropological spotlight onto the very academia that she is a part of—examining and evaluating how those in her department interact with one another in a university setting. Immensely talented and intelligent, Marshelle has had a hard time reconciling these gifts with the cultural stereotype of who she should be as an African American. She lives in Oakland, California.*

Because my mother was an extraordinary soprano in the church and community, I felt uncomfortable. I didn't want us to be too talented or too much. *Shining your light* didn't mean anything to me except that people would get resentful. In elementary school I didn't want to answer all the questions that I knew the answers to. The message I got from kids pulling my hair and teasing me was that if I wanted someone to like me, I had to tone down who I was.

I went to Phillips Andover Academy boarding school when I was thirteen. I always knew what racism was, but when I got there, I was clueless for the first couple of years. I had *The Preppy Handbook* and that blue-and-green purse with the whales on it, but by junior year, I was a nationalist. I was like, "We came from Africa. How dare you try and make me read Shakespeare?" I got bitter.

But high school showed me a glimpse of what I could be. The school had a *white male* perspective in that, as a student, you are the center of the world. For example, there is nowhere you can't go and nothing you can't do. I got into that mentality. I was singing in the Cantata Choir and traveling to Spain and other places. I was directing plays, receiving Latin translation prizes. Everything I tried to do I was really good at. Then, at some point, I looked at myself and subconsciously wanted to sabotage my success. I was afraid that people would not love me if I was not who I was stereotypically supposed to be. I felt like I had to tone it down.

Truthfully, the question was, "Are black people still going to like me?" I didn't have any question that I was black and that I was down with gospel music and church. Whatever the checkpoints were to being black, I knew that I met them all. But there were these other parts of me, too. It seemed as though Andover was stressing that we were the most special of where we came from. So I got into this "Oh God, I'm so different. How can I go back to Baltimore and talk to my family because now I can translate Latin, speak Greek, etcetera."

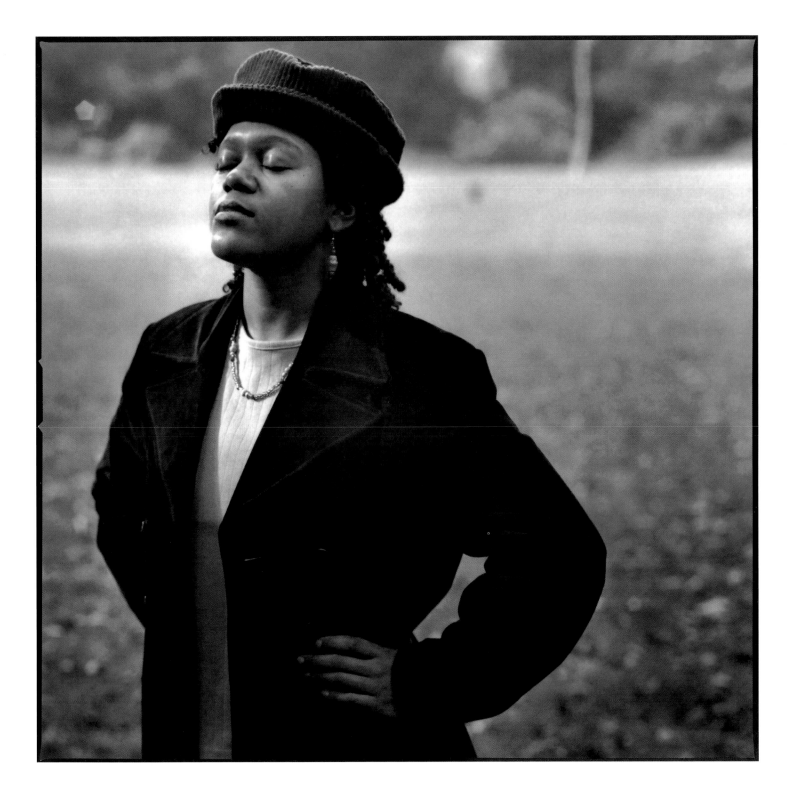

In 1994 I realized that I had pushed myself as far down into a box as I possibly could, and it didn't feel good. I had lived long enough to say, either I am going to claim all of who I am or I am going to die spiritually, and I didn't want to die. I knew that it could lead to a physical death as well. If there is anything I want my life to be about now, it's "Embody it and enact it."

When I have children, I will teach them, "No one is your enemy. No one is your friend. Everyone is your teacher." There is divinity in everyone and in every place that we go and a purpose for everything going on around us no matter how bad or good. I will also teach them not to give up their power to whatever images people might have of them.

Today, I can talk to people about Shakespeare or speak "standard English." But if I am in East Baltimore talking to my great auntie, I can talk to her in a language that she can hear. As a black person in this country, I feel connected to all people. Human beings are infinite. There is nothing I can't relate to, connect with, or learn from, nowhere I can't go, no person or spirit I can't connect with. In high school, I started to see myself as a category and as a construct. That's where all these belief systems win. That's where we begin to think of ourselves in bioevolutionary terms: the survival of the fittest, as separate entities, seeing things like money and food as scarce, so we create poverty. That belief system makes poverty inevitable because we have internalized it. The white woman who clutches her purse may just be having a bad day and be thinking about her husband who beats her. But if she is walking by me, as a black person, I will think that she did that because I am black. Maybe she did. But that doesn't take away from the infinity of who I am.

Where I am now is getting those destructive voices out of my mind to the point that I don't put myself in the box that has already been constructed for me. What other people do I can't control, but I can control how I respond to it.

I thank Silvia Winter for the idea that as humans we live in stories. We live in narratives about what it means to be human and what it means to be a good person or a bad person. So if I see a professor in the hall who has written a book about how horrible it is that street children in Brazil are getting killed and how there is a need for an activist anthropology, and then at the same time she can't speak to me, or the secretary who works for her, or the guy who cleans the department, I will see a disconnection there. There is no congruence between her thoughts, her words, and her deeds.

For me that is more data on how we as human beings in a university culture behave. I don't need to go to the museum because that is not where life is. I just need to come to her office hours. To me the knowledge of anthropology is in how we interact with one another, not what we learn from an exhibition downtown.

Marshelle Jones

# Maria Armstrong

Born February 12, 1968, Barcelona, Spain      *A child of divorced parents, Maria grew up angry and fiercely independent, but when her father died in 1995, she found that she could finally let go of a lot of her bitterness and pain. She saw opportunities in her life that she never imagined before, and she helped start Raising Expectations, an after-school tutoring program that goes far beyond traditional assistance with classes. She has dedicated herself to a life of service, and the children and their communities are benefiting immensely because of it. She lives in Atlanta, Georgia.*

**My middle name, Escarlata, is part of who I am and where I come from. Now as I am getting** older I am more ready to claim it and not be so afraid of it. I was born in Barcelona, Spain, and lived there for the first six or seven years of my life. I was a little black child who spoke Spanish and it was cool. Then my mother, father, and I moved to North Carolina, and everything was so black and white. Before that I didn't really look at black and white. My mother looked white but she wasn't white to me. She was Spanish and my father was black.

**My parents' marriage was not by any means a happy one. From what I saw it was awful. There** was a lot of chaos in the house. They divorced when I was twelve. After that I had to grow up quickly taking care of my younger brother.

**Their divorce has definitely affected the way that I see men. I don't believe I would get into** a similar relationship or marriage, but I know that I am a little bit harder on men than I need to be. I am a huge challenge for a lot of them because I am strong and independent. It is not because I am trying to be a feminist or anything, but I am just trying to take care of me. My mother taught me one thing and that was not to be dependent on any man.

**It seems like men have very precious egos. They feel less of a man because of my independence** and strength. My fear is to put myself in a situation like my mother's. I feel very responsible for my life, and I have all the control to have the life that I want. I have women friends who will say about a man, "He has a lot of potential." I don't deal with potential. I realize that if I meet a man and there are certain things that he doesn't have, then I can't change him and it is not my duty to change him. If he gets there on his own, then maybe we can work something out.

**When my parents were together I wasn't happy. I acted out so much, and all the time, for attention.** My father was on drugs and passed away about two years ago from lung cancer. That was a huge

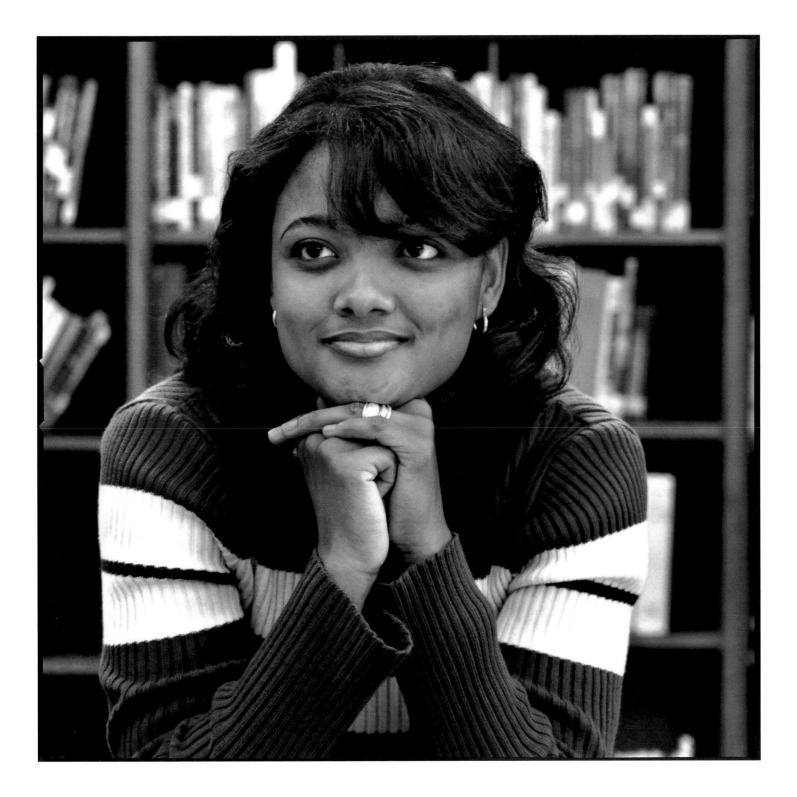

turning point in my life. For the first time, I really started to think about life and what it meant to me. I let go of a lot of anger and hostility I held toward him and saw things that I never knew were there.

Now little things make me smile, where seven or eight years ago they didn't. Service and giving are two of those things. I think they are the reasons why we are here. It is the whole purpose of living. I don't believe it is about my personal goals, my gratifications, my degrees, how big a house I can live in, how many cars I can put in my garage, or how many designers can be in my wardrobe. That is not what life is about. If we all looked at service as the reason for our being, then all of our needs would be met. No one would be on the street without food, and children would get the education they deserve.

The children that we are tutoring mostly come from impoverished communities where there are a lot of drugs. During the day you will see a lot of young black men hanging out on the street and beer bottles everywhere. This is where most of the kids start out. We started by tutoring them in the neighborhood library, and when parents saw what we were doing, they became interested and asked us to tutor their kids as well.

One of the things that I try and teach the children is that you can't lose if you dream big. Reach for the stars. Why not? Every day I hear low expectations from the high school kids when they say, "I just want to graduate," or "I want to go into the army." Spirituality is very important to giving them higher expectations because from that you get a complete understanding of life and what life really means. I have a young lady who is having difficulty getting to class because she runs out of energy getting her daughter ready, and then getting herself ready. No one else is around at home to help her. So something as simple as me calling her in the morning to wake her up gets her to class on time. Now she is interested in getting her grades together, and she is taking notes when last week she wasn't taking any.

I absolutely love working with the children. I learn so much from them. Whatever it takes for them to see and realize the potential they have in this world, I'll do it. Once they realize that other people do care, they will start to have some confidence in themselves. They'll say, "Someone believes in me. Someone is not negating me or breathing down my back every time I step inside the house. Someone is actually believing in me." I don't even want to deal with all of the stuff

that they have done in the past. I know that some of them have been in juvenile detention. I know that they have done this and done that. But I am not dealing with it because then I would just become the same person that is trying to hold them down. I deal with what they can do, not what they have done.

Many people think of volunteering community service as giving somebody something. I see the children helping me grow as a person just as much as I am helping them realize their potential. That allows me to do what I do. From a humanistic standpoint we all have a choice in what we do. All of us can decide what we want in this life. If people through their work could help others grow a hundred years ago when they were getting beaten and lynched, what makes me think I, or my brother, cannot do it today with all that we have. I accept complete responsibility for all the choices I have made. Whether I like them now or not, I learned something from them and I have moved on. I believe in my heart that I can have whatever I want in my life if I really want it. Nobody is going to stop me. Regardless of where I am or what I am doing, I have come to the point where I can say that I am who I am supposed to be because I have that much faith in life.

# Maria Armstrong

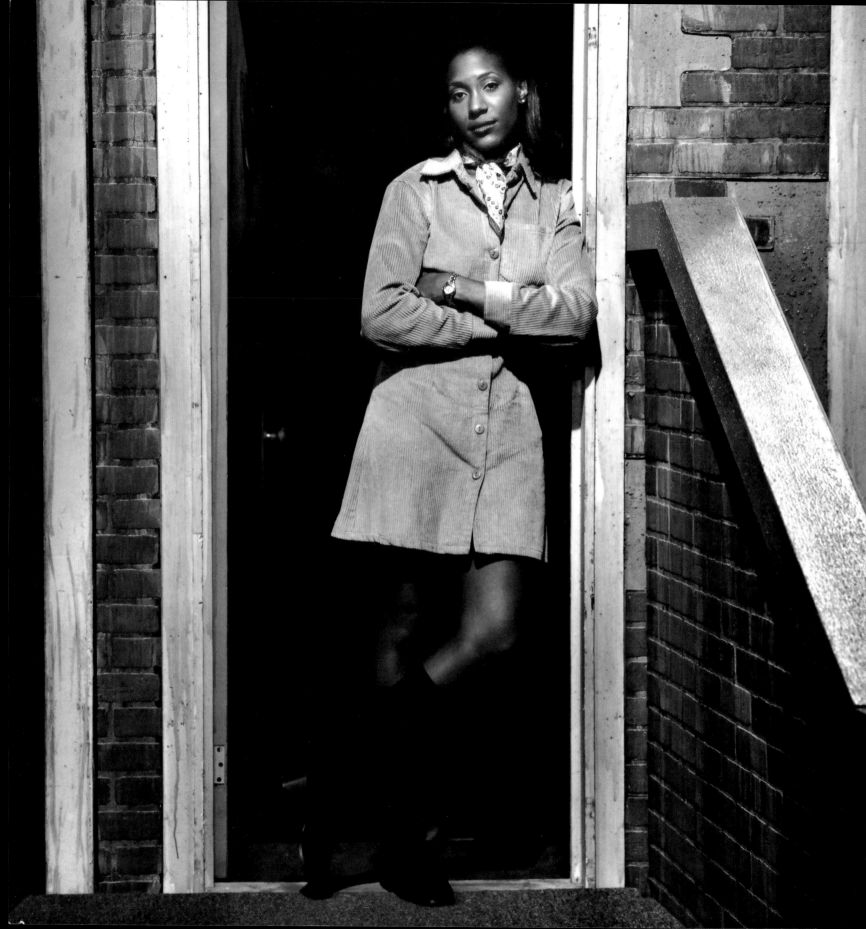

# Francine Toliver

Born March 17, 1969, Washington, D.C. *Young African American women receive many mixed messages these days, especially about sex and relationships. As cohost and producer of Black Entertainment Television's* Teen Summit, *Fran is at ground zero of the debate, helping to shape which messages these young women take to heart. Every week Fran and the other cohosts moderate discussions, present celebrities, and offer opinions designed to make young adults of the hip-hop generation think about and question the world they live in. Fran knows all about the self-doubts and self-delusions young women go through, having experienced them in her own life, and she is in a unique position to capture her audience's attention. She lives in Bethesda, Maryland.*

When I was younger, I never had a boyfriend or any male paying attention to me. I am one of those chocolate sisters whom people would badly tease because I am so dark. Once they started paying attention, I wanted to make sure I kept them, so I became everything they wanted me to be. In all cases the relationships ended up not working. Unfortunately, I learned that much after the fact. You may make a mistake on Monday of 1989, but you don't correct it until Wednesday of 1997. But now I can be alone. I don't want to put up with stupid crap from a guy who is juggling women. I can wipe up my tears from being alone and move on.

I found my true strength after going through a horrible engagement. There were a lot of things about the way my fiancé treated me that I didn't want to tell people because it was so embarrassing. I felt as if nobody else was going through it. Little did I know everybody else was, or had been, in similar relationships. All women have good investigative skills, but when I found out he was cheating on me, I did some searching to find out who he was with. It backfired in my face when he claimed he couldn't trust me. Then he moved in with her. I was miserable, sad, and depressed, but no one knew.

With a lot of help I started to see that it wasn't necessary for me to take what he was giving me. Eventually, I moved on with my life and things started to happen for me. I got on air. I know, without a doubt, that I would not be on television today if I had stayed with that man because he was never there for me. He was not emotionally supportive. As ugly and unattractive as he thought I was, I would never have had the confidence to do it.

On air today I get to look at young women who are going through some of those same things. Some of them are really out of control. They don't care anything about etiquette. I am not saying that a woman should be seen and not heard, but we have all heard young girls cussing and screaming in public. They talk about what they like, how they like it, when they like it, and how hard they like it. They think it is cool to talk that way. Sexuality is not something sacred. The mentality of many girls today is just like the guys. They think, "If guys have been doing it for years, then we can do it, too."

It's a difficult time for some young women because their moms are a collective group of single mothers who are themselves fairly young and still dating like they're without children. This is the example that many girls are getting. Worse yet is that their mothers had moms who did not talk about sex or relationships openly. So, they're at a loss, too. It's hard for a young mother of a sixteen- or seventeen-year-old girl to say, "This is what you should be doing." Even though I don't like to look at things in a negative light, I do think we are not going in the direction we should be. We need to be more open about sexuality. We have to let girls know that they don't have to give it up to everybody and anybody. We need to start talking to them about the differences between sex and love.

We also have to let them know that they don't need to settle for somebody. I want more out of a relationship. If he can't give it to me, then there is no need for me to keep hanging around and wasting both of our time. I don't know where we as women learn that we have to settle. We probably get it from those same people who tell us that there aren't any good black men. When you hear that, it becomes easy to go ahead and settle for a halfway decent one. It becomes the new thought process: if I can find one who is not beating me, doesn't drink or smoke, and he is having sex with only one or two other women, then that's a brother to hold on to. We don't need that.

I have grown so much and worked so hard on myself that I know I deserve the very best. I deserve the best financially, mentally, spiritually, and physically out of the person who will be my partner, especially if I am bringing something to the table myself.

Although I know these things about myself, I don't think God's plan has been revealed to me yet. I'm striving for what will make me a good person and be able to share it with others. One day I will be that person. I won't be perfect, but I will be better than I was the day, and the year,

before. I will be able to look back on the way I was and say, "Wow. I did make some changes."
Whether it is through my work on air or my writing as a producer, it will happen. But if I don't
work hard every day at what I am currently doing, nothing else will come along from God's plan.
He knows when you are not ready to move to the next level. As a result, he will not open that
door for you to go through. When I pray now I ask for things every once in a while, but I mostly
thank him for taking care of me and my family.

**Francine Toliver**

# Teiahsha Bankhead

Born November 7, 1966, Los Angeles, CA *Teiahsha's commitment to and passion for the African American community is perhaps most inspired by her grandfather, who was white, and her grandmother, who both volunteered to house a continuous procession of blacks relocating from the South during the forties and fifties. She is currently co-authoring a book on interethnic relations with noted psychologist and author Jewelle Taylor-Gibbs. She is also the director of program development for the Bay View–Hunters Point Foundation, where she writes grants for the health and social service agency and is responsible for securing their annual budget. She lives in Richmond, California.*

There was a lot violence where I grew up. There were a lot of people who were AFDC recipients, and I did hear gunshots. But I was in a family of support, encouragement, ambition, and expectation. So, in some ways, what was occurring all around me was not my reality.

As a single parent, my mother was able to shape my life and give me the opportunity to develop my individuality. I never felt any restrictions on what, who, and how I could be in the world. I received my understanding of the world from reading books, and I learned to get beyond the closed environment that I was raised in. My grandfather was a white man. He had to almost relinquish his identity as a white man to be with my grandmother back at that time. He was probably one of the most dominant male figures in my life.

Almost one hundred people lived at my grandmother's house during the forty-five years that she owned her home. They didn't just pass through for two weeks as they were trying to relocate; they moved their things in. My grandparents had that parental role to a lot of people. That part of my grandmother—the giving, accepting, and welcoming—lives in my mother and lives in me.

There are lots of people, no matter where you are from, who are not receiving the support and encouragement that they need. These folks need to find mentors. They need to approach folks to ask for guidance, to be willing to go out and say, "I need help." I did that all the time. I still do! Most of the people I know are willing to respond to that call. And if I can't myself, I'm still driven to try and connect them to someone who can.

I am passionately committed to a healthy black community. One way to attain it is through groundedness in spirituality. I interviewed twenty imprisoned men for a book I assisted Jewelle

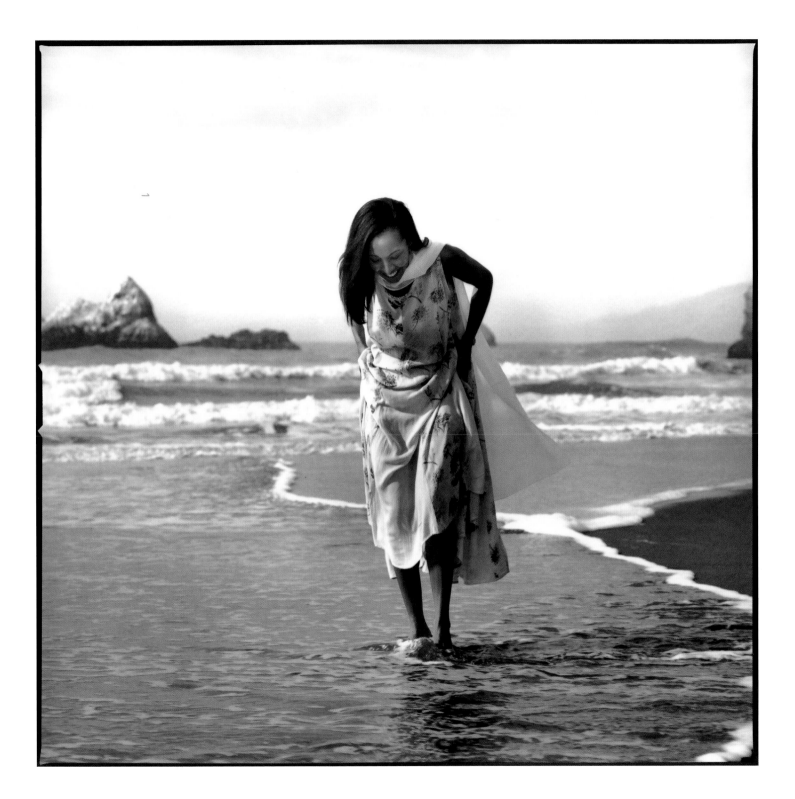

Taylor-Gibbs with. All of them were African American, and all were there for rape, arson, or murder. I asked them, "To change the low employment, low incomes, and high school dropout rates, what is the single significant issue in need of improving in the black community?" To my surprise, they said, "Grounded values and morals. We need God in our lives." The human spirit is so capable of doing, and black youth, particularly, feel as though their spirits were injured early on — to the point that they are not able to grow, develop, and really soar.

One of the things my aunt said to me was, "You are everything that you ought to be. Your goal in life is not to try and change yourself, but to try and understand why your behavior is so perfectly appropriate." Whenever I am faced with a big problem, instead of immediately trying to change the situation, I try to think of how this came to be in my life. Black women are grounded in our spirituality. We have achieved an awful lot. We are wonderful mothers. We are loving and generous and nurturing. But we need to be more focused and more purposeful with men, with our bosses, and with other women. We need to balance being honest and gentle with being courageous and strong. And it's true we all need to be more active to make and save more money. But I don't think that is the most significant thing. The black middle class is rising. African Americans are becoming satisfied with a level of consumerism and material wealth, but we aren't doing the corresponding intellectual development, and the spiritual and psychological growth that we need. I think we want to be rich but we are not seeking true riches. We are seeking rich material gain and it's not enough. Additionally, we need a political voice. Although we are stakeholders in the future, we are not a group that legislators give a damn about. They don't care because there are no repercussions for excluding us. We need to hold our elected officials accountable, lobby, and run for political office.

I am an African American woman. I don't say I am a woman who is African American. At different times I wear different hats. When I am alone with my journal, I'm just me, Teiahsha. But the blackness, the African American status, permeates my life. Because I have this body in this world, people see the African American part first and the woman second, and I use both of those things. It's wonderful being a woman. We are powerful and sensitive. We are so strong and in control. We can be sensitive and take care of people, but we can also be taken care of. It's okay to be all of those things.

I have never desired to be a man. I'm sure I have fantasized about having certain kinds of access that men have, infiltrating an all-men's club, listening to some of those conversations. But I think the conversations I have with men, and the ones I am privy to, are probably much more interesting anyway. I couldn't be anything other than who I am.

Teiahsha Bankhead

# Lorraine Johnson

**Born October 13, 1961, Los Angeles, CA** *Lorraine has a congenital anomaly of her hands, which means the growth process was halted while she was in her mother's womb. After her birth, doctors performed reconstructive surgery and formed work-able digits to work in conjunction with the thumb and forefinger she did have. As a child, she suffered from low-self esteem, and she believed she would never be able to accomplish anything, but the support of her father and her desire to prevent others from sickness inspired her to persevere. She has now realized her dream as a doctor of chiropractic medicine. She lives in Altadena, California.*

A turning point in my life came during high school when I was about to drop out. The counselor called my father into the school and told him he should take me out of Algebra 1 and Biology and put me into Modern Science and Algebra XA. That way I would be able to have a good grade-point average. He also said, "Obviously, she is never going to college, so why don't we just help her GPA in these slower classes to make it easy for her." My father said, "What are you talking about? My daughter is going to college." I, on the other hand, was sitting there thinking, "What are *you* talking about? I'm *not* going to college." But my dad never let go of me. He just kept pushing that I was going. The more he said it, the more I started to build my self-esteem, and the more I started to believe I could do it.

His believing in me brought me to where I am today. Throughout my life I have wanted to help people before they need emergency care. Eighty percent of the sick population is that way because of things they can change in their lifestyle. My thinking was that if I could educate people about some of those changes, maybe the people I see won't have to become sick. So I decided to go to chiropractor school, and while I was there my friend confided in me that one of my instructors didn't think I was going to make it through the class. He was concerned about my hands. I said, "Huh. What about my hands?" He had told her that because I didn't have fingers he didn't think I was going to be able to do it. Up until that point I had never thought about it. I had never really thought about my hands since I was a girl. Now that they are my specialty, I am intrigued by them.

In school they taught us about landmarks on our hands. I didn't have some of those landmarks, so I would instead use my index finger on my left hand for everything. I learned to adjust. There

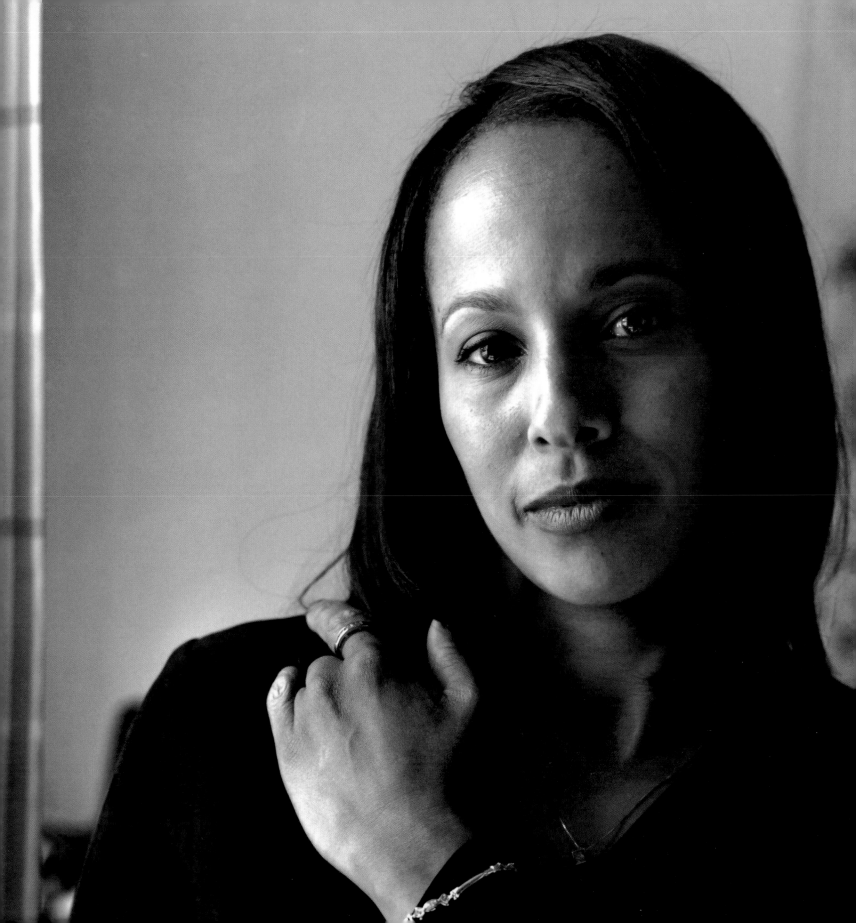

were so many people in the class that you couldn't possibly know everyone, so many of them didn't know about my hands. Often, when I worked on classmates, they would tell me that I had a nice touch. They kept saying that. One time someone said, "You have such a big strong hand." I said to him, "You would be surprised." I joke about it because I'm not uncomfortable about it. People are uncomfortable if you are. I can't change it, so why should I try and hide it. It's like being black, and I can't change that either. It's all about exposure.

When I was young it was a different story. I was very sensitive about the way my hands looked. The kids would tease me and be hurtful, so I would hide them all the time. My goal at the time was just to blend in. Don't stand out. I wasn't the pretty girl in the school, and boys weren't singing my name all over the place, so I just focused on blending in.

It's funny. Blending in highlights one of the greatest things ever to happen to me. It happened the day I became a doctor. When I walked on to the area where commencement was being held, I saw all of these people who had black robes on. It wasn't until that moment that I realized I was a part of them and they were part of me. Ten years before, I never would have thought that I could become a doctor. And some years before that, I didn't think I could become anything. It is the greatest moment in my life. The moment I bent down and had my hood placed on me as Lorraine Johnson I knew I had achieved everything that I had ever wanted to. I thanked the Lord in a silent prayer and stood up. I knew I wasn't the same person anymore. The person before was self-assured but still had doubts here and there. She was determined but fearful. The person with the hood on was a lot more fearless and adventurous. She felt good about herself.

It was important for me to hear them announce "Dr. Johnson" when I received my diploma, so that my father could hear his name with the title in front of it. I'm not hung up on it, but it represents an accomplishment. Now when my father calls and asks for "Dr. Johnson," he can get a kick out of it.

I stand for possibility. Anything is possible if you put your mind to it, set a plan of action, and execute it. I never set goals for myself while I was growing up. Things would just happen. And they often didn't happen the way I wanted them to. All I ever have really wanted to do is encourage someone else to do what they want to do, whatever that is. When I speak to students, that is what I always tell them. There are, and will always be, roadblocks. There will never be enough

money or time, but if you really want something, you can circumvent yourself around those issues. I had twelve hundred dollars to start this business. That was it. I knew that I needed to get in gear. I have other friends who started the same way, and they are now doing quite well. Where there is time, there is hope. You don't know what can happen, and you can never predict the positive things that are waiting to happen.

Lorraine Johnson

# Tracey Salmon Smith

Born January 8, 1965, Brooklyn, NY　　*Tracey is a successful assistant United States attorney in the civil division of the Office of the U.S. Attorney in Brooklyn, New York, but she still finds she has to prove herself every day. Law enforcement agents are frequently nervous to see an even-tempered African American woman in charge of their case, but those same agents are consistently won over after witnessing Tracey's negotiating skills in the courtroom. She and her husband, Loyston, are expecting their first child in August 1998. She lives in Rosedale, New York.*

When I was growing up my parents always had the attitude that I could do whatever I wanted to do. But they would also say, "Be the best at whatever you pick." When I was choosing my career, my father stood behind me the whole way and never told me that it was something I couldn't do. My mother has also been encouraging, always telling me to be independent and self-supportive and do the best that I could. That last piece of advice is so important today because many high school girls and young college women feel as if they need to have a man to be complete.

I didn't grow up with the attitude that I needed a man to make myself complete. That, in a way, scared off some guys. Just after graduating from law school there were nights where all I wanted to do was hang out with my girlfriends, but the guy I was seeing would get a little intimidated with that independence and with the fact that I was a lawyer. At one point, I went so far as to not really tell men what I did. When they asked, I would get around it. Then I realized that what I was doing was ridiculous. If a man couldn't deal with it, then forget it; it wasn't worth it to be with him. Many men say they want the independent woman, but I don't think they really do.

What's interesting is that I don't see much difference in being a man or being a woman, and I have always looked at things from that perspective. I have never let people put me in a different category just because I am a woman. As a lawyer I am very sensitive to being treated differently. The focus should not be that I am a woman lawyer as opposed to a male lawyer. Some people may attribute the qualities of an attorney, being driven and having ambition, to men. But woman can, and do, have all of those qualities as well.

I see people trying to highlight the gender difference in my work environment. Since some of my cases deal with forfeitures from the proceeds of drug activities or illegal activities to the government, I deal with city, local, or federal law enforcement agents. Sometimes I get a bit of an

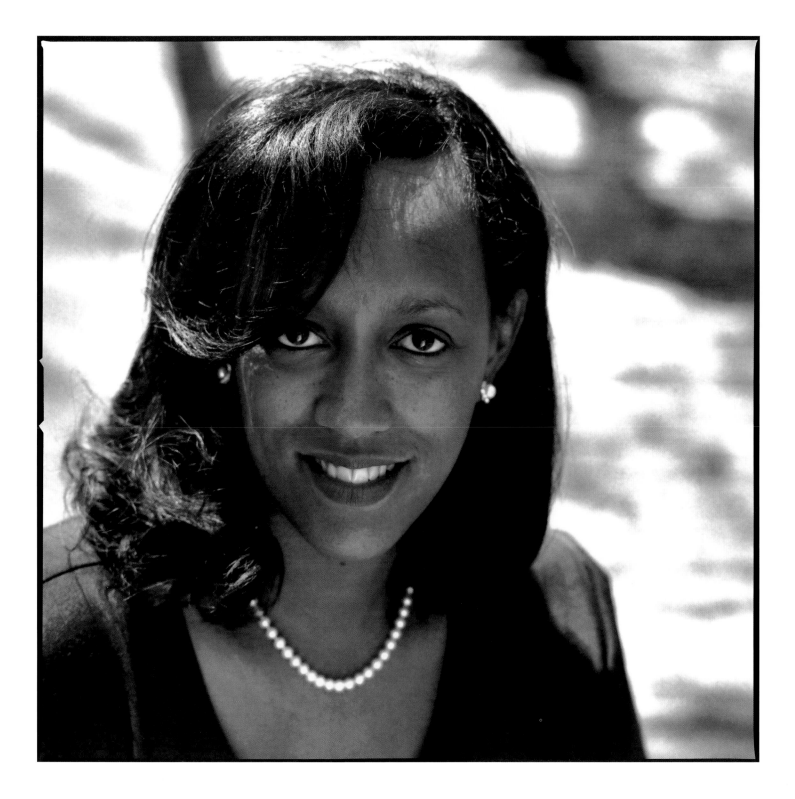

attitude from them, indicating they are concerned that I am a woman. They wonder whether I really know what I am doing. I just think to myself, "Yeah, I know what I'm doing and I'm very good at what I do. There is no need to worry." Their suspicion might not be spoken outright, but I get a feeling from them. It happens especially when I am working with another assistant district attorney who is male. The agent may then start directing questions toward him. I usually show them that I know what I am doing, and I do the best job that I can do. Often, they do come around. In fact, the other day an agent was giving me vibes that told me he wasn't comfortable with my ability. After we went to court and I negotiated the case for him, he said, "You really had to do a lot of work to get that order from the judge." It was a dawning for him. Now we have a different relationship.

I am not an aggressive, in-your-face attorney like some other women attorneys around here. There are some male attorneys who are like me and know what they are doing, what they have to do, get everything done, and know everything doesn't have to be a fight. You don't have to constantly be in another person's face. You can make your point without all of the yelling, the screaming, and the carrying on. People may expect it because they are watching *NYPD Blue* and other television shows, but it's not necessary and it doesn't always work. If you are comfortable with what you are doing and you use your own personality, it will send you a lot farther.

My career is very important to me, but my focus will change in August. I'm pregnant and expecting my baby then. I want to be there for my child, and my future children, and give them what my parents gave me. That's important. I am going to have to make some adjustments in my work and the other activities I am involved with, but I will continue to do the best work that I can. I may need to make adjustments in my working environment so I won't be in the office as much. Some serious balancing is going to be needed. Outside of that I don't know what I would change about my life. I have always plotted out what I have wanted to do, and now I am doing it.

# Tracey Salmon Smith

# Moneek Reid

Born July 6, 1971, Pasadena, CA *Sometimes a store is just a store, and sometimes it's Café Soul, where you can find everything from barbecue sauce to imported African art—as well as lectures, fashion shows, and activities focusing on health, wellbeing, and overall spiritual growth. Moneek, its owner, has created a store that's as much a community center celebrating African heritage as a place to sell merchandise. But this exuberant businesswoman is also a mother of three children—Aziba Eshe, Akilah Isoke, Iamme Rashaad—who enjoys the challenge of making it all work. She lives with her children and their father, Ashombe, in Altadena, California.*

I didn't know I was American until I went on a business trip to Africa. I am a descendant of Africans, but as my consciousness grew, I realized there were many things that made me American: everything from the way we eat to the way we consume everyday products. Consumption makes us American. Being in Africa made me aware of the simplicity I wanted my life to be about. People showed their love for each other and appreciated each other. They weren't afraid to show it. They weren't afraid to hold hands. To see brothers and sisters walking down the street holding hands loving and appreciating each other was wonderful. It did something for my soul because I saw black men deal with each other on another level. I believe it's the norm in all African cultures, but in this country we don't let the expression flow like we should.

Being connected to the African continent has given me a sense of self. It's given me a sense of achievement in that I now know we were the first people on earth, and in my eyes, we will be the last. It's given me a spiritual connection to all lands. One good thing about not knowing where my lineage comes from is that I can pick any place on the African continent to establish a link. I have this vast place to choose from. I may look like I am from Ethiopia, but I may decide to use some of the traditions of, maybe, a South African, or maybe, somebody from the Ashanti tribe. It is my choice because I don't know exactly where I'm from. It's the only way I can look at it without getting angry, and there is enough in our history to be mad about. I could be mad until the day I die. I am not past anger, even though I have grown and entered into another school. But I haven't forgotten what I learned at the first school. I am now beginning to *overstand* myself.

Part of my new awareness is from my role as mother to my babies. Being twenty-six years old with three babies can be a challenge. I am finding that it is not even so much the challenges

I give myself every day but the challenges of everyone else's expectations that can wear me down. Doing two and three things at the same time is nothing for probably anybody, but sometimes it can be tiring, and when that happens I just have to sit back and think, "I've been given the strength and the energy for a reason. So I need to use it." I can't harp on the negative because negativity breeds negativity.

Usually when I'm out with my kids, people will say, "Wow, how are you doing with three kids?" And I say, "My momma did it with seven, so don't even trip." I just do. It's not really a burden or a blessing. I just handle my business. Remember, their father is great and is part of everything, so I do have help. I am not a single mother. But if I was, I would still handle my business. It's part of life. That's what we're put here to do: breed and procreate.

Since children are our future, we need to teach them right. I want to teach mine to love themselves and to know that they are not separate from anything that they see. They need to know that everything is connected and they are blessed. If they move on the righteous path, they will continue to be blessed. I will teach them to be creative and open. To let things flow to them as they should because everything is a lesson. I want them to be careful in the things that they do and the things they say because everything is energy. If we speak with a negative tongue, then that is the action that will follow. The things we do and the way we live our lives represent where we want ourselves to go and the type of lives we want to lead.

A big part of how I came into this state of mind was through books and meditation. It came from taking the time for myself. It is helping me succeed with Café Soul, even though there are a lot of people who don't expect me to succeed. They are a big problem because they are the same people who don't want you to be an entrepreneur or to be revolutionary. We have a lot of envy in our community. They don't want you to support your culture or to love your culture. Some of them don't even want to see love as being black. I love being black. I love nappy hair. I love the big lips. I love it all. I love the creativity of our people. I love the depths of our soul. And when I say "soul" I mean the physical manifestation of our creator. I also mean "soul" as mind, body, and soul. You feel me? A lot of times it hurts to be black. It ain't easy being black. It's a journey and a struggle, but without struggle there is no progress. Right? I love the challenge. I don't love the fact that there are not enough of us opening up our own businesses. But there are also a lot of

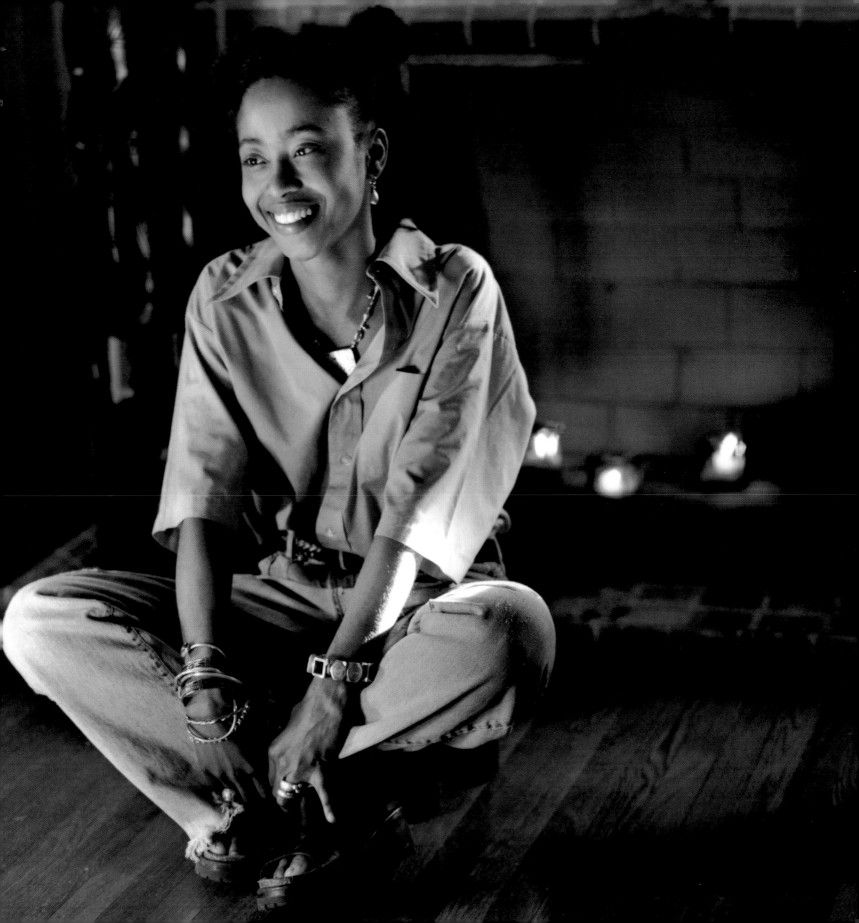

people who believe that I better succeed because if I succeed, we all succeed. I am glad to say that I am doing it, and because of the wonderful support I did receive, I am making something happen in this community.

Things have rolled my way and things have come to me the way that they should. Sometimes I asked for it and sometimes I didn't. Either way, the blessings keep rolling my way. So, obviously, I must be doing something right.

## Moneek Reid

# Lea Hicks

Born November 11, 1967, Ludwigsburg, Germany  *When Lea's parents met, her father was an American soldier on tour in Germany, and her mother was a Slovenian expatriate pursuing a career as a classical pianist. Their interracial marriage wasn't controversial overseas, but it certainly became so when they moved to the United States with their daughter. These early experiences had a great influence on Lea, and they are part of what make her the caring and empathetic doctor she is today. A surgical resident at Highland Memorial Hospital, she is highly critical of this country's cold, male-dominated approach to medicine and surgery, and she refuses to let her dedication and love for her patients be dimmed by its largely anonymous health care system. She lives in Oakland, California.*

There was no color in my life until I was thirteen and moved to the states from Germany. I noticed, getting off the plane at the North Carolina airport, that people were staring at my parents. In Germany there were many interracial couples, and I don't think people cared. It wasn't something that directly impacted my life. In North Carolina, people would stare with a look of *why are they together?* When I was fifteen, a plumber came to the house to fix something. My mother was in the kitchen, and when I came down to get a sandwich, the plumber dropped his equipment. After I was gone, he said to my mother, "Weren't there any white men where you were when you were looking to get married?" Hatred. He was wrapped in absolute hatred.

I see myself as Lea Hicks, a brown person. Brown is one of my favorite things in the world. But I don't like categories. They're so boring. It starves the spirit. My father is African American and my mother is Slovenian. So what? And? I have a certain culture. I am aware of my father's culture. I love my father's culture. I love my father's family. I love my father. I love the same things about my mother.

I remember the first time I went to Savannah to see where my father came from. It was so different from anything I had ever seen in Europe. He grew up in a very poor family with seven brothers and sisters. His family is very traditionally southern and African American. I couldn't believe how segregated education was there. My high school counselor would say, "You don't want to go to Georgetown for college." I was so disgusted. How can you accept someone telling you that you are *less than?*

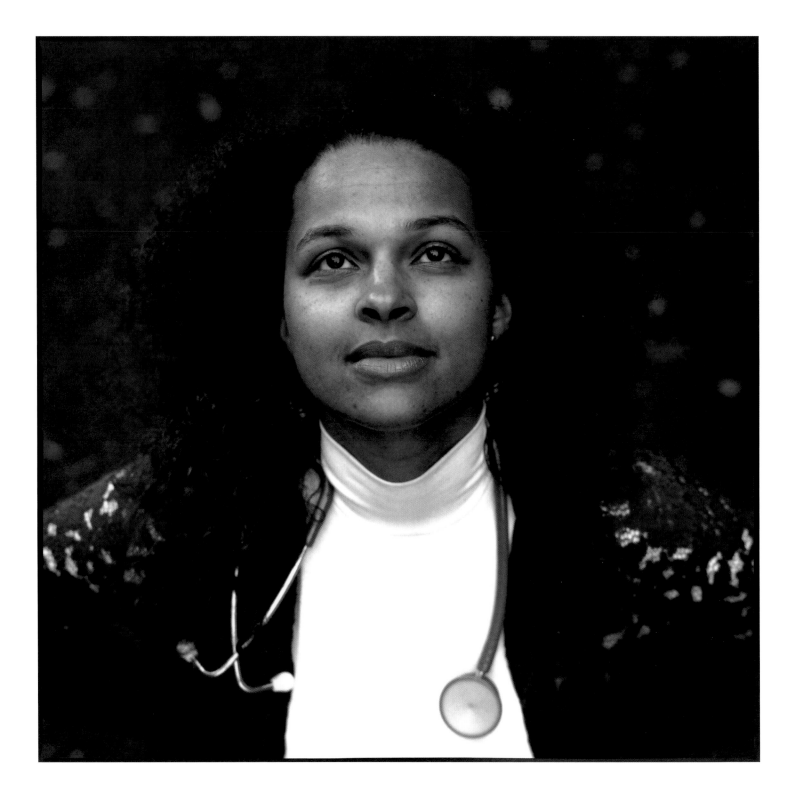

**I got very upset in medical school when this one woman had a miscarriage.** She was black and very young, maybe twenty-one. She had twins, but it was a premature labor and the boys were stillborn. She was delirious—making indecipherable sounds and no sense. No one in the room stopped. Nobody said anything. It was just something normal that they simply planned to continue with and that's that. I went over to her and tried to console her a little bit. I couldn't stand it, so I left the room. I had to see another patient and went to check her urine sample to see whether her water had broken. I went to this dirty, closed, utility room where they throw away junk and other dirty stuff and in that room were the two babies. They were dumped on top of the garbage can in a blue plastic sheet. It was unbelievable. Now, a lot of it had to do with the fact that she was a young woman, and she had been given absolutely no emotional support. But another thing is that they were black kids. You can't help but wonder. In this huge institution where she and I were the only black people in the room, this multimillion-dollar facility, where everything is brand-spanking new, I couldn't believe there wasn't a respectful space for these children.

**Some doctors just depersonalize situations.** The thinking is your body has the disease and you need me to get rid of it. You as a person don't matter. I think a lot of people operate that way. They take their soul out of their work. It's so easy. Patient care becomes an assembly line, and because of the stress, patients are emotionally put in little boxes. That approach to medicine makes me wonder whether I can finish training in this country. I went to one of the best medical schools in the country, and it was really fantastic. But there was no spirituality. You become just another number, and it is about paper. It didn't measure, encourage, discuss, or include any art into the science of training in medicine today. Medicine is a complete discipline. It is complete dedication. Every day is a wonder learning something new. I adore the science of medicine because it's not ambiguous. I like finality and I like order. I like the rhythm of surgery and how it feels. It is also an opportunity to meld with someone. Connect with people who trust you. It is such a wonderful way to love someone.

**Traditionally, surgery has been male dominated.** Men have this amazing ability to disconnect from feeling. I think men have issues with love. Everything becomes work, sport, or money. Since men dominate surgery, they expect a woman to behave like a man. They expect you to dress like a man, to operate like a man, and to talk to your patients like a man. Men operate like a German

train station. The train has to be here at nine o'clock. There is no chaos. There are no disruptions. That's how men are.

I think women are more flexible. Time is measured more in the emotional exchange. How long does it take a patient to understand what this is all about? We sit down on the bed and explain to patients what is going on, and it may take half an hour, but it's important that they understand. A man comes in, looks at the vital signs—temperature, blood pressure, heart rate, respiratory rate—and asks if there are any problems. There are lots of women that are just like men, but I think the God complex is emotionally a male thing. You are in a very powerful position as a doctor. Many people have trained for so long that they lose perspective and become wrapped up in themselves.

Medicine is about life. The beginning of life and the end of life, but it's all life. You can't be a physician without loving life. It doesn't work. Maybe I take it for granted because that is who I am. I am supposed to be a healer. I am supposed to be someone who brings joy and who brings life.

## Lea Hicks

# Jena Roscoe

Born April 14, 1969, Washington, D.C. *Jena's parents were active during the civil rights movement in the sixties, and they have passed the torch to their daughter. Jena's activism is also inspired by summers she spent as a child in a small, segregated southern town. Today, Jena is living her convictions—she is the special assistant to the deputy director of the Office of Public Liaison, which briefs the president on the concerns of the African American constituency. She lives in Washington, D.C.*

My mother's hometown, Kershaw, South Carolina, was very segregated. Occasionally, I would spend summers and Christmases there, and a great part of my life has been shaped by this small town. My parents fought hard during the civil rights movement. They were adamant in telling me that because they fought for integrated societies, they would make my sister and me grow up that way. In Maryland, even though it is a southern state, we grew up in an integrated suburban area. My parents were the first black people to move into the neighborhood, Temple Hill, in Prince George's County, Maryland.

In Temple Hill, I was going to school and living in the midst of integration, then in Kershaw I was in an entirely segregated venue. As the years progressed, my family's activism came out in me. In Kershaw, I would walk from my grandmother's house to my aunt's house for an hour along Main Street, and that entire walk would be the whole town. White people lived on Main Street, and black people lived on beaten dirt roads off of Main Street. When you went down the street, blacks automatically let white people walk in front of them. I wouldn't allow or accept things like that happening to me.

I remember how hard it was to fight for what was right. In elementary school back in Maryland, my best friend was a white, Jewish girl. I didn't know her as Jewish, and she didn't know me as black. We were friends. But in order for her to be in the "in" crowd, she had to ditch me. She told them that I was her best friend and that we could all be together. But they told her that I was black and that it couldn't work that way. In order for her to be with them, she needed to be away from people who looked like me. Jody still couldn't get it. Eventually, she took the "in" crowd because that's where she wanted to be. That was when I first realized that I was black. I didn't really see what all of it meant until I was told that I couldn't have my best friend anymore, but I remember thinking, "It's their loss." I saw people for what they were rather than seeing their color. Unfortunately, it is often a negative situation that breaks many out of that innocence.

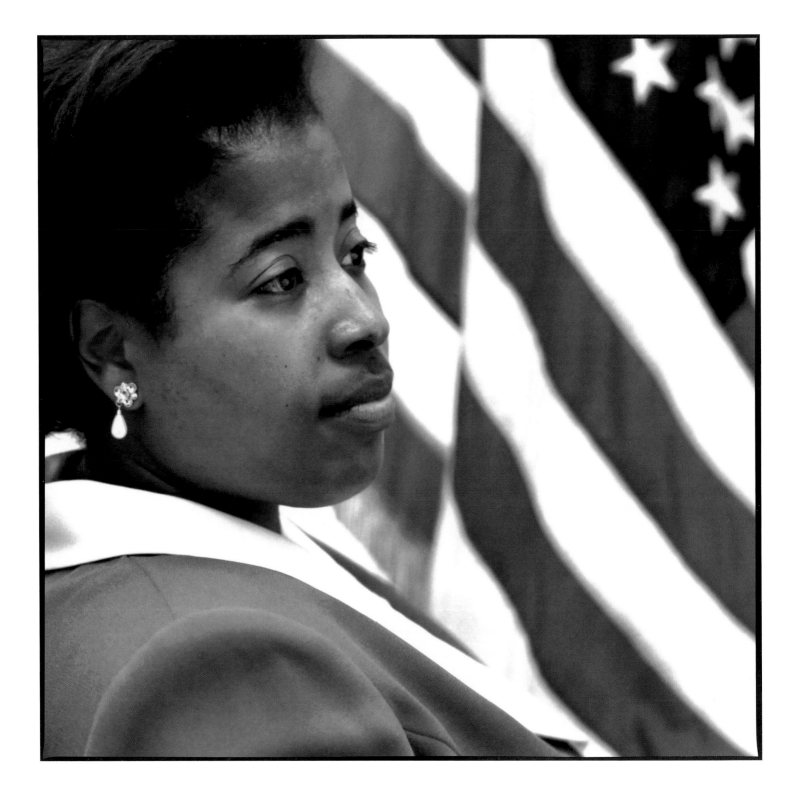

**In my job, I am aware that being African American means that we are not immigrants. We were** slaves and fought very hard for our freedom. We fought for the right to be called Americans, and now that we are, it is important for us to be involved in all processes of American society. If we have an opportunity to dictate policy, or to serve our country in whatever capacity, then we should be proud of doing that. And that's what I am. Proud.

**Some concerns that the African American community want our office to bring to the president** deal with the fact that African Americans built this country. We are American citizens and feel that our lives have been invested in this country, which therefore makes it our country, too. We want to be a part of every process. We want to own our own businesses. We don't want to go into a bank and be denied a loan because of how we look. We want to be able to live the American dream and have the same opportunities that everyone else has. We want to be Americans.

**Working for the president of the United States is the greatest thing to happen to me. It is a** tremendous honor to be able to work for the United States. Another great honor took place during my freshman year at Howard University in 1987. I was able to walk into the Supreme Court building and see Thurgood Marshall—the Supreme Court's only black man at the time— sitting on the bench. He was representing African Americans and representing America. The Supreme Court represents American law and acts as the caretaker of law in this society. For him to be there said to America that we were at the table. It said that we are Americans and we matter. Additionally, for him to have been a part of the Brown vs. Board of Education decision eliminating segregation in the school systems and then to be a pivotal presence in American law sent the wonderful message that we were integrated in this country.

**But even though that is true, you can never be removed from where you come from. I can never** be removed from the African continent. In 1987, I went to Africa. African Americans are 13 percent of the U.S. population. In Africa blacks are the majority of the continent. It wasn't until I went there that I realized I was a part of a majority populace, and I was only a minority in the country in which I lived. Because of that single fact, I can't take away that I am African. I am both.

**Traveling to Africa showed me that there was a world out there that I was living in. I am not just** going to sit around and let life go. I have to be part of it. We are not here that long. Why not do whatever you can to better life for everyone? Since I am an American, why not do work to better

America and then the world? My parents taught me that I should do whatever I think is right and go for whatever I believe in. I should give it my best and give it my all. I don't have to be loud about it. I just need to be steadfast and consistent. I have seen it in their lives, and I think it has helped me shape my life in what I am currently doing.

## Jena Roscoe

# Bridget Goodman

Born March 18, 1965, San Francisco, CA          *Bridget was enveloped by a sense of loneliness throughout much of her childhood. When her mother died from negligent hospital care, and after her family sued the hospital and won, Bridget struggled to find her way through life. During her search, her self-confidence and self-esteem waned. Then, when she was in college, she decided to enroll in an academic exchange program with an art school in Germany, and she granted herself a clean slate to pursue her dream to become a painter. She has since parlayed her natural talents into a position as a view painter (the person who digitally adds color and texture to computer models in films) with the leading special effects company in the country, Industrial Light and Magic. She lives with her son, Eastway, in Tiburon, California.*

My mom died when I was five, and my two older sisters and I were adopted by my mom's parents. My grandparents had three children: my aunt, uncle, and my mom. They had lost my uncle and my mom early on, when they were both younger than I am now. I think those losses traumatized them to the point that they decided to shelter us from everything. Looking back on it, I would have been a rebellious child, but I was afraid of causing them too much pain because of their age.

Not having my mom and being raised by my grandparents was hard. I realize just how hard it was whenever I look at my son, Eastway. I see how he always has his dad around, and it seems obvious to me that children just need someone to look at almost as a mirror of what they might become as a woman or as a man. Thank God I had my aunt. I didn't see her all the time because she lived in Oakland and I lived in San Francisco. But I tried. When I was in third grade I would visit her at her work at I. Magnin and get perfume and clothes. It was what I needed at the time. I didn't have that kind of relationship with my grandparents because of their generation. So, developing my own identity, understanding completely who I was, why I walked a certain way, or talked a certain way, was extremely difficult. I never really felt rooted, but somehow I always knew I needed to improve myself. When something like losing your mom at an early age happens to you, you don't have answers, and sometimes you don't have someone who just allows you to mourn.

My stepfather filled that role for me. I think that was his one saving grace. When my mom died, my grandparents didn't allow us to go to her funeral, but my stepfather sneaked us in because he understood something they didn't. He gave me and my sisters our last opportunity to see our

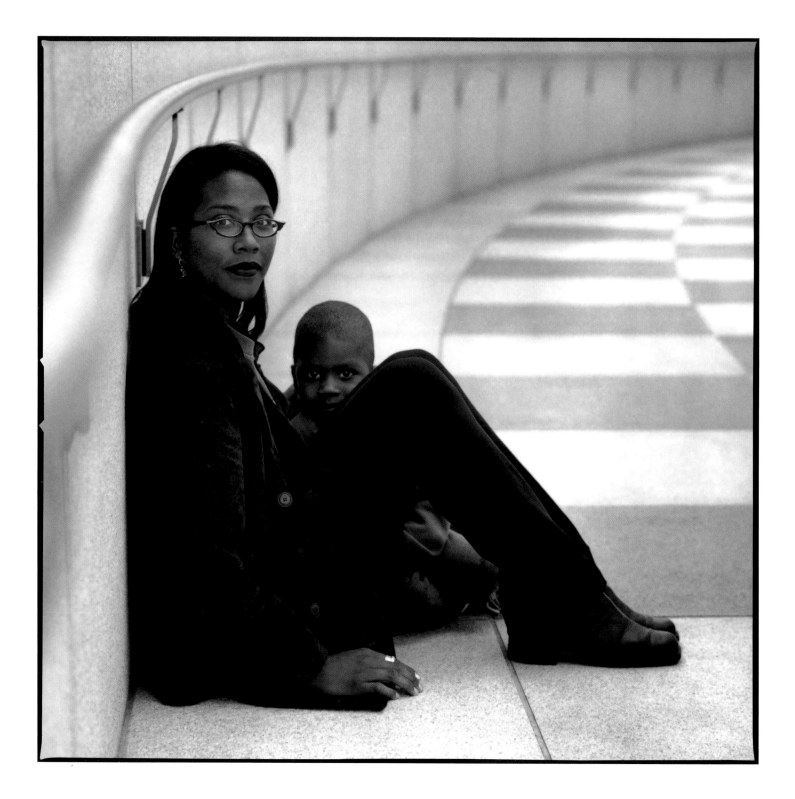

mom. The last image I have of her is of her lying in the casket. She had this beautiful lacy chiffon dress on. Her hair was beautiful and she looked stunning. I remember just being happy seeing her. I have that image to hold on to forever. It was then that I knew our mom was gone, but also that I have parts of her in me.

It was a wake-up call when my grandmother died. That is when my aunt and I really bonded. I can remember getting up the courage to ask my aunt for a cigarette in the hospital snack bar. Having the strength to ask let me know I was coming into my own because I realized what my choices were. I told myself that since grandmother was now gone, and my grandfather had passed before that, I had no one else. It was just me. I had to make decisions for myself, and the first major one was going to Germany for art school.

Being black in the part of Germany I was in, Braunschweig, was interesting because, for the most part, I was the only one. There were some Cameroonians enrolled in the nearby university but they never really came over to the side of the city where I was. So the people in town found me curious. I didn't speak any German when I arrived, so I just roughed it. The little kids wanted to touch my braids and talk to me in German, but I couldn't speak their language. I felt more alone than when my mom died. Even though there was no one to control me anymore, and I felt an immense amount of freedom, I also felt a lot of loneliness. But even with these feelings, moving to Germany was a pivotal point for me because it allowed me to finally catch up to my destiny and my path. That path was utilizing my talents and gifts, and it allowed me to start taking myself seriously.

Before moving to Europe I was studying nursing. But after my grandmother passed, I knew I couldn't have any more death in my life. I stopped studying nursing and decided to study art. I had been drawing since I was a kid. When I went to Germany and enrolled in the H.B.K. Art School, the people there gave me the confidence I needed. But along with that, I had to deal with my own sense of humiliation as well. It came from not having a formal art education. I had taken art classes while I was studying at San Francisco State University, but I still felt as if my fundamentals were simply picking up a pencil and just trying to do something. The program was part of a private exchange with SFSU and I am sure that the director there convinced H.B.K. to accept me. But even with my previous classes and his support, I don't think I was aware of the

fine line between doodling and actually creating something. There was a whole intellectual side to art that others had experienced but I hadn't. Once one of my German teachers pulled me from class, took me to the library, pulled books off the shelves, and dropped them into my arms. In the end, I had ten huge books on different artists and he told me, figuratively, to eat them. He left me standing there thinking, "This is bad. This is real bad." But it was all a way to learn what I am doing now at ILM.

When I walked through the doors at ILM for my first interview, I felt the magic. Three days later, I started as a receptionist. I did that job for eighteen months, but during that time I took drawing and Photoshop classes. So I was promoted to a model sculpting job, but I always wanted to be a painter. And now I am. In fact, I think I am one of the first employees to cross over from administration into computer graphics.

My confidence has just continued to grow with each year. Professionally, and personally, it started when I moved to Germany. It grew as I pursued my painting job. Finally, I gained a great deal of security with myself when I gave birth to my son. Having him was so empowering. I felt secure about being a woman and experienced the power of life tumbling around inside of me. That power let me know a higher power exists. I may have the control to eat, sleep, etcetera, but I have no control beyond that. Before giving birth I first had to give myself up to this powerful thing. Then, at that point, I went into labor. If I could just make a film about that feeling it would be awesome, and it would constantly remind me of how lucky I truly am.

# Bridget Goodman

# Sienna McLean

Born January 3, 1969, Cambridge, MA  *Sienna was raised in the small town of Plainfield, Vermont, a predominantly white community of artists and artisans. Her African American father and white mother divorced when she was five, leaving her with few memories of her father. Despite this, she treasures her African American heritage, and like many mixed race individuals, she struggles to reconcile her identity in both worlds. Sienna received a masters in documentary film from Stanford University in 1997, and she has expressed her cultural connection in her four documentaries:* This One Roof, Teach, Shadow Dancing in My Ancestors' Footsteps, *and her last,* Still a Revolutionary, *which was screened at the 1998 Sundance Film Festival. She lives in San Francisco, California.*

**Surprisingly, I feel connected to a community of African Americans, but I know that I look different** and may not really fit in. My hair is straighter, and you can't tell from looking at me that I am black. Even though I look white enough to easily live within the white community, I don't feel as connected to it because I know they are not recognizing other parts of who I am. When I am around other people of ambiguous race, I feel comfortable and connected because there is less that I have to explain.

**When I think of identity and my connection to the world, I think of women and a strong female** community. I have a lot of strong, wonderful women in my life, especially my mother and my grandmother on my father's side. My mother is an incredible woman and my grandmother has been a strong presence in my life.

**In general I want my films to open people's eyes to aspects or experiences that they may not** have considered previously. I don't want to tell people how to think or what to think. I want people to be able to walk away thinking, "I never thought of it like that before." I have an attachment to documentary filmmaking because it's about real people and real stories. There is something about it that is so much more moving and so much more profound than a feature film. I am not asking an actor to come perform in front of a camera for me. Instead, I am sitting there with this woman who was present at that rally, at that time, and she is sharing herself with me.

**When you talk to people about their lives and their experiences and why they do what they do,** you establish a relationship that is so much more meaningful to me than anything that is fiction.

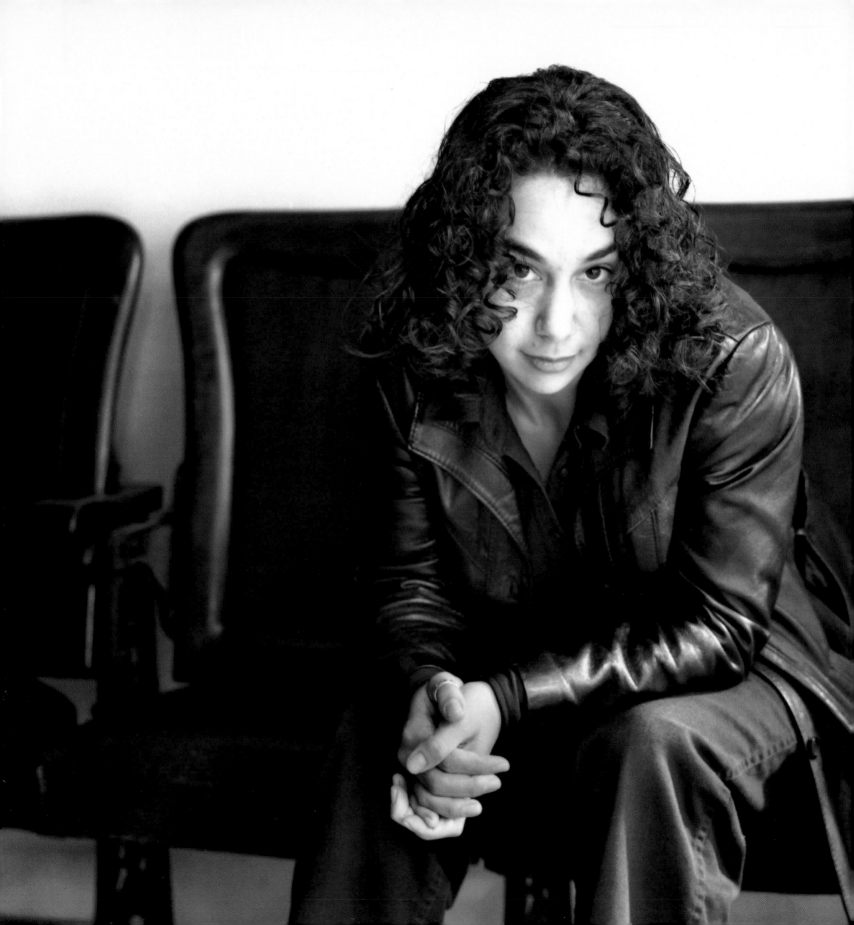

My last film, *Still a Revolutionary,* is about two women who used to be in the Black Panthers. They reflect on their experiences in the Black Panther party, the passion that moved them to join, and their confusion and pain when they knew they needed to leave the party. From them speaking about their roles within the party, I hope it sparks people's interest in the Black Panthers and the Black Power movement of the sixties and seventies. I hope it will move people to learn more about what was happening at that time because a lot of people don't know anything about the Black Panthers. They don't know who Huey Newton and Bobby Seale were. All they know is what was in the media at that time and that's it.

It is important to know about the Black Panthers because they persuaded a response to many of the same things that still exist today. They are misrepresented historically, and I think very few people know about the community service programs they initiated. Instead of just being represented as these gun-toting, militant racists, they should be given a lot of credit for what they were doing for their community. There is no doubt about it, their image was sabotaged by the government. But I don't want to be *teaching* anyone about the Black Panthers in this film. My intention was to be specific to two individual women and their experiences within the Black Panther party. I want people to come away from it recognizing all of the hundreds of people who were involved in the party that were never in the media and nobody ever knew anything about. I also wanted to convey a story of passion and what leads people to put their life on the line. These women thought that they probably would die before it was all over. Now they are in their mid-forties and they have children.

What's interesting is that when I approached the two women in *Still a Revolutionary,* they made certain assumptions about me and my background. They looked at me and probably said to themselves, "Yeah. She's a mixed-race person. Probably part African American." But I don't think they felt threatened by me because I don't have a threatening presence. But when I went to the Black Panther thirty-year reunion picnic last October to meet them, I felt very out of place. The way that I look was definitely an obstacle. My personal connection to the African American community is something that is not recognized externally. I feel like I am connected but yet I don't feel legitimately connected because I don't think that African Americans look at me and think of kinship. I am certainly not going to go up and say, "Oh, you know what? I am actually half African American." I would never approach anyone like that. It's hard and it will continue to be hard.

When it comes to identity and being of mixed race, it will always be confusing for me. Even if I am certain that I'm a mixed-race woman and I don't need to define myself in terms more specific than that, it will always be confusing because of the outside pressures to define myself. Two years ago when I decided to try film, I had all of these doubts about my life. Now I have no doubt about what I am supposed to be doing. I feel grounded, centered, and certain that I am in the first stages of becoming who I am supposed to be and doing what I am supposed to be doing.

At this point in my life I feel really good about embarking on something huge, unknown, and terrifying. The excitement of the sense of accomplishment and the limitless options that lie ahead of me. Well, I realize that they are not limitless and that there are areas that I will crash into. But it is the first time in my life that I have known what I want to do, and I have found a way to express myself, to articulate my values and priorities. It's through film and sometimes other people's stories that my self-expression is conveyed.

Sienna McLean